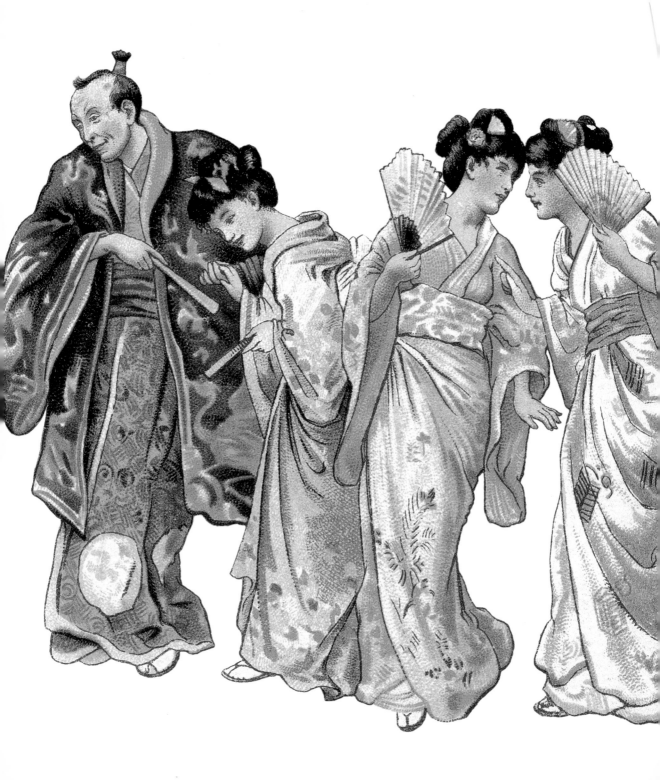

Victorians at Home and Abroad

VICTORIANS AT HOME AND ABROAD

Paul Atterbury and Suzanne Fagence Cooper

V&A Publications
Distributed by Harry N. Abrams, Inc.

First published by V&A Publications, 2001

V&A Publications
160 Brompton Road
London SW3 1HW

Paul Atterbury and Suzanne Fagence Cooper assert their moral rights
to be identified as the authors of this book

Distributed in North America by Harry N. Abrams, Incorporated,
New York

ISBN 0-8109-6573-9 (Harry N. Abrams, Inc.)

A catalogue record for this book is available from the British Library

Designed by Bernard Higton

Printed in Singapore

Every effort has been made to seek permission to reproduce those
images whose copyright does not reside with the V&A, and we are
grateful to the individuals and institutions that have assisted in this
task. Any omissions are entirely unintentional and details should be
addressed to the Publishers

Jacket illustrations:
Front: Henry Nelson O'Neill, *The Parting Cheer* (detail). Oil on canvas,
1861. Private collection.
Back: Poster for *The Mikado*, 1885. See plate 20.

Opposite Introduction: John Absalom, *View of the North Transept
of Crystal Palace* (detail). Hand-coloured lithograph, 1851.
V&A: 19538.21.

Harry N. Abrams, Inc.
100 Fifth Avenue
New York, NY. 10011
www.abramsbooks.com

CONTENTS

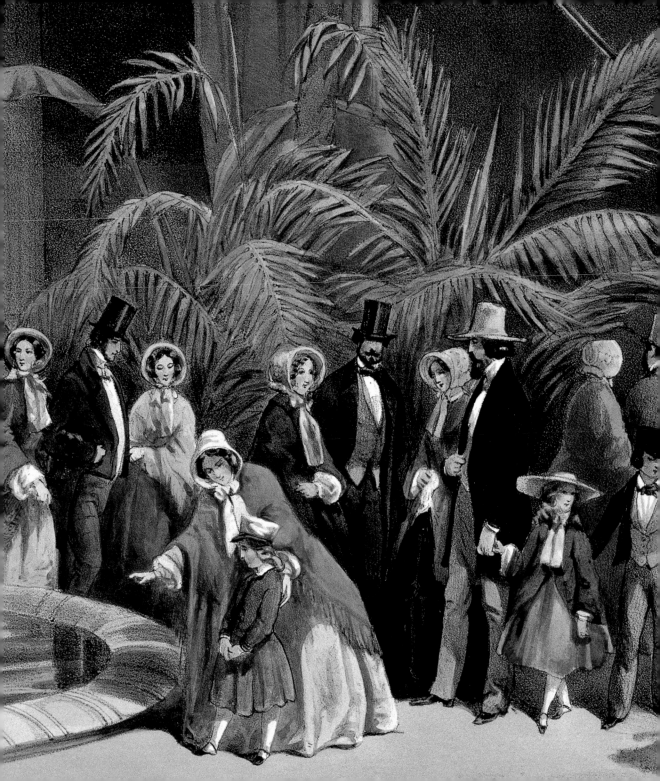

INTRODUCTION

On 22 January 1901 Queen Victoria died at Osborne House on the Isle of Wight, bringing to a close a most dynamic period in British history. At the time of her death, despite the increasing threats posed by rival European countries and the rising commercial power of the United States, Britain still controlled the largest and most successful trading empire the world had ever known. During her long reign, which started quite inauspiciously in 1837, Victoria was the figurehead of a country driven by social, economic, political, cultural and philosophical change. The manifold achievements of the Victorians influenced millions of lives across the British Empire and laid the foundations of the modern world. At the same time, the overriding confidence that characterised the Victorians was matched by a willingness to face up to the challenges posed by uncertainty, insecurity, social divisions and disaster.

Since the Queen's death, the vision of the Victorians has been clouded by subsequent judgement and interpretation, to the extent that the actual nature of their society and its achievements has become unclear. The centenary of her death offers an opportunity to look at the Victorians as they really were. This book reviews some of the essential components of the period in a direct way, providing an overview of Victorian attitudes, achievements, society and culture. It is presented in five sections, each of which highlights a major area of achievement, change or debate.

The first section looks at the influence of the royal family and their role as patrons of art, design and science, and instigators of social change. The New Britain of Queen Victoria, constructed around the vision of British history represented by the revived Gothic style, was all-encompassing: new democratic principles and political systems, new views on education and industry, new family values, new materials, production methods and markets.

The second section concerns itself with ideas that changed the fundamental structure of Victorian society, many of which drew their potency from the success of the Great Exhibition of 1851. These include the completely new attitudes to travel made possible by the train and steamship, new approaches to the pursuit of leisure, new technologies that revolutionised both home and workplace, new concepts in medicine and public health, and the emergence of modern consumerism backed by marketing and advertising. Parallel, but not always in step, were new debates about the ethics of work, about religion and death, and about sex and the role of women.

The third section concentrates on changing attitudes towards nature, as landscape, as style and decoration, as the context for the exploration of the relationship between animals and man and as the setting for the major philosophical and religious debates about the origin of man. The fourth section explores the style battles of the Victorians, highlighting the conflict between imaginative historicism and the pursuit of new ideas in art and design. In the final section, as part of this debate, the focus of attention is on the Victorian's vision of the wider world as they encountered new cultures through expanding imperialism and trade.

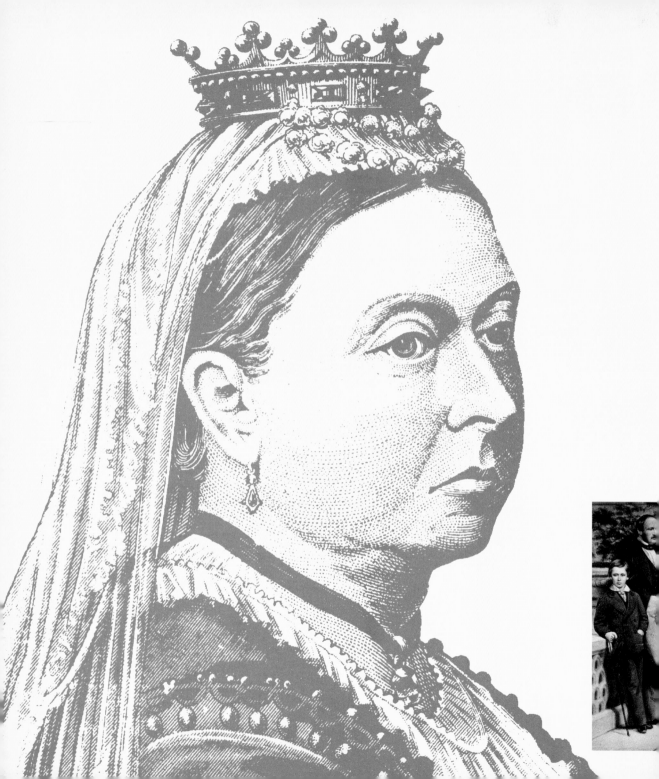

ROYALTY AND THE
NEW BRITAIN

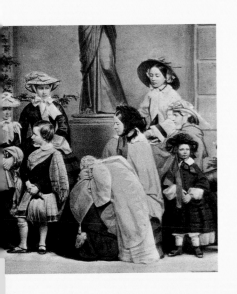

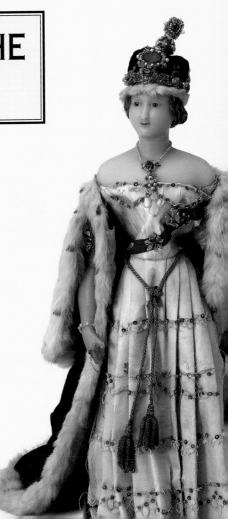

IMAGES OF QUEEN VICTORIA

Victoria, the only daughter of the Duke of Kent, was born in Kensington Palace on 24 May 1819. Upon the death of her uncle, William IV, she succeeded to the throne on 20 June 1837, and was crowned in Westminster Abbey a year later, on 28 June 1838, at a time when public support for the royal family was at a low ebb. Victoria's wedding, on 10 February 1840, to Albert of Saxe-Coburg-Gotha, in effect the first royal event to seize the public's imagination in the modern manner, rekindled public enthusiasm for the monarchy. Popular souvenirs and mass-market images gave the new Queen, and her young Prince, a familiarity hitherto unknown to British monarchs. Through paintings, photographs and illustrated press reports the royal family became public property. This new familiarity was underlined by coins and, more importantly, the new stamps that depicted the Queen with a degree of realism unknown to earlier monarchs. The pattern, and habits, established in 1840 continued throughout Victoria's long reign, and her image, and the images of her family and associates, were constantly in the public domain.

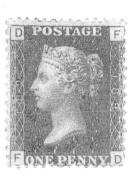

2 (above). Penny Red stamp. 1854–64. Private Collection.
The penny post established the basic principle of all modern postal systems, namely that a standardised pre-paid flat fee could cover the cost of delivery of a letter anywhere. The first adhesive stamps, the Penny Black and the Twopenny Blue, were introduced in May 1840. From the start, all stamps carried a recognisable depiction of the Queen's head in profile.

1 (right). Queen Victoria doll. Wax, 1840. Bethnal Green Museum of Childhood, London.
Dolls depicting Queen Victoria, made without any royal licence or permission, underline the accessibility of the royal image. Several are known, including this British-made example, depicting the monarch in the Royal Wedding robes. At this time there was no control over use of the royal image, or even the royal arms, and so they were often commercially exploited.

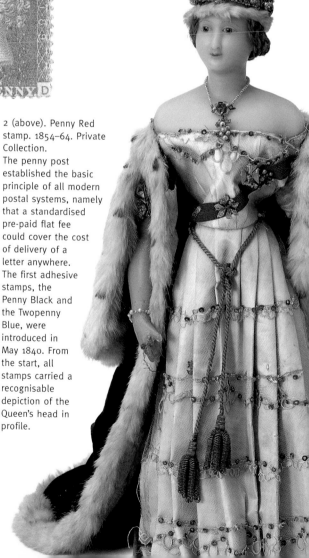

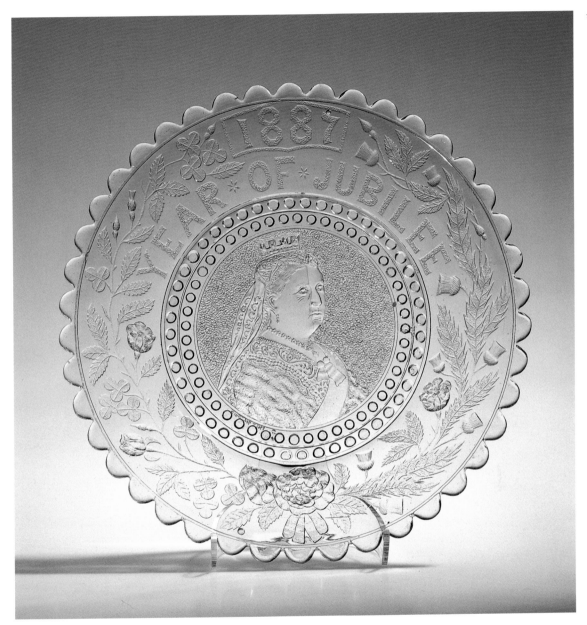

3. Souvenir plate. Pressed glass, 1887. Henry Greener, Wear Flint Glassworks, Sunderland. V&A: C.61-1983.

Commemorative souvenirs were made in huge quantities throughout Victoria's reign, but the high points for public enthusiasm were the Golden and Diamond Jubilee celebrations in 1887 and 1897. A typical mass-market souvenir is this pressed glass dish made by an industrial glass moulding process developed during the 1840s.

THE FAMILY

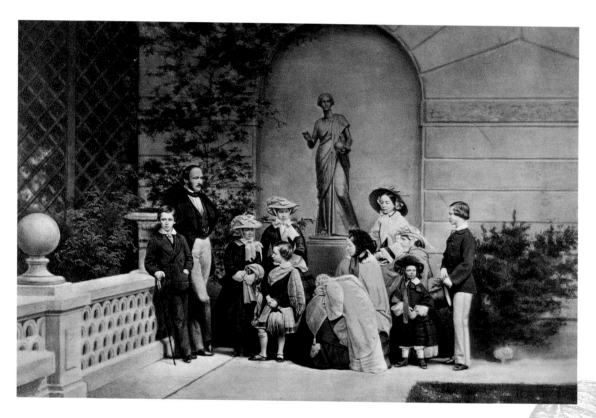

Depicted throughout the nineteenth century with increasing informality by painters and photographers, Victoria, Albert and their nine children became important role models, redefining the family, and establishing in a broad sense the family values that are still at the heart of British society. Even the portraits by Sir Edwin Landseer, Franz Xaver Winterhalter and others, while showing the continuing impact of seventeenth- and eighteenth-century formality, make a statement about the modern family in which parents, children and animals exist in the kind of informal harmony indicative of new attitudes towards domesticity. Highly visible and relatively accessible, the royal family was a cultural model and an enduring influence for change, representing an ideal of family life that became rapidly a middle-class institution and then spread, with greater or lesser success, to all levels of society.

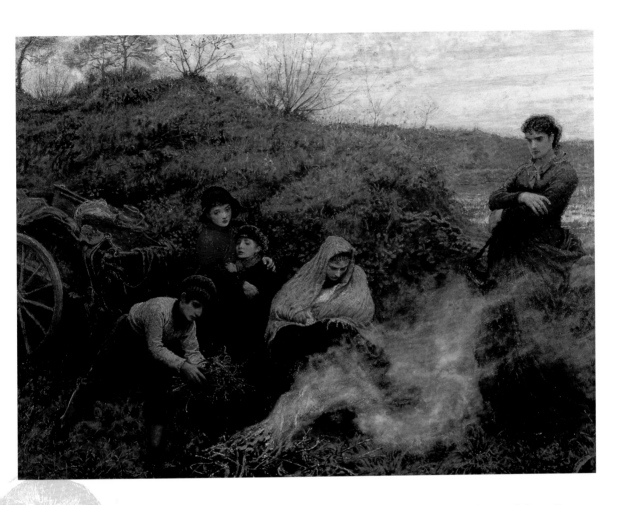

4 (left). Leonida Caldesi and Montecchi, *Queen Victoria and the Royal Family at Osborne*. Photograph, 1857. V&A: 68:021.
From an early date the royal family made themselves accessible to photographers, and the camera was a powerful presence at royal events. Osborne House on the Isle of Wight was the setting for many of the more informal photographs. The close-knit nature of Victoria's extended family was revealed by these images, which made them more accessible as the model for the new style of British family life.

5 (above). Frederick Walker, *The Vagrants*. Oil on canvas, 1867. Tate Gallery, London.
Divisions in Victorian British society were openly acknowledged, along with the different approaches to family life that these represented. This painting shows a family living outside the conventions of society that nonetheless still operates as a family. It illustrates the realities of their lifestyle without the rustic sentimentality of late 18th- and early 19th-century artists such as George Morland and Thomas Rowlandson.

CHILDREN

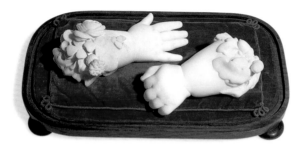

The Victorians were the first to regard children as independent creatures with their own particular needs, rather than miniature adults. It was the role of the Victorian family to turn these independent creatures into sensible and useful adults, using the tools of play and education. The huge expansion in the production of toys, games and children's books during Victoria's reign reflected the emergence of the child both as an independent being and as an increasingly powerful consumer. This aspect was underlined by the development of the modern Christmas as a family celebration, with the emphasis on jollification, children and present-giving.

A reasonable education was seen by many Victorians as the ultimate right of every child, regardless of background. Various government acts worked towards this ideal throughout Victoria's reign, the most important being Forster's Education Act of 1870 which established school boards and enforced minimum standards, and the Education Act of 1880 which made school attendance compulsory for all children aged between 5 and 10. The spread of government-controlled, publicly-financed education was supported by other new laws planned to control, and eventually eradicate, child labour. By 1901 the minimum working age had been raised to 12, and children up to 14 could only work for half a day.

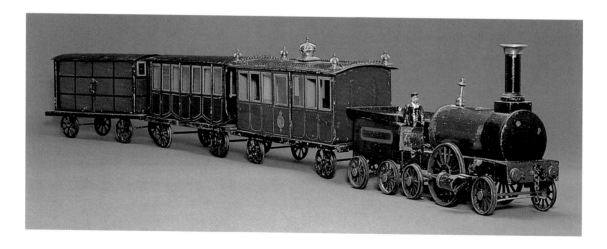

6 (top left). Mary Thornycroft, *Hands of Victoria, Princess Royal.* Marble, 1843. The Royal Collection © HM Queen Elizabeth II.
Painters, sculptors and photographers produced increasingly realistic portraits of children in an attempt to capture a permanent record of something ephemeral, a desire underlined by the high levels of infant mortality. Marble or wax copies of the limbs and body parts of small children were popular, such as these, commissioned by Queen Victoria.

7 (bottom left). Model of Queen Victoria's royal train. Probably by Lutz, *c.*1875. Photograph in *Childhood: A Loan Exhibition of Art* (Sothebys, 1988).
Miniature trains made as toys rather than engineering models were popular from the 1850s. Most were made in Germany, a country that became famous for the production of automata, dolls and metal and printed tin plate mechanical toys. Early toy trains of the type shown here, while modelled with considerable accuracy and detail, were designed to be played with on the carpet rather than to run on rails.

8. Christmas tree decorations. Blown glass, taken from moulds *c.*1900. V&A: C.323-1993.
Although the 25th of December was a Christian festival by the 5th century, Christmas is, in effect, a Victorian invention. As so often, the lead came from the royal family, and the royal Christmas tables, complete with decorated trees, special foods and presents quickly set a trend. The idea of the decorated tree, established by Prince Albert in 1841, had been imported from Germany, and many of the ornaments also came from there.

GOTHIC AND THE NEW BRITAIN

Decorative Gothic was part of the popular design language in late eighteenth- and early nineteenth-century Britain, but it was not until the Victorian period that it acquired a political voice. In the early years of Victoria's reign Gothic became, to quote its most fervent proponent, August Welby Northmore Pugin, 'not a style but a principle.' The cult of medievalism became absolute and Gothic a modern political philosophy. In a country busily reinventing its history, the medieval style went far beyond decoration. The actual foundation stones of this New Britain were industry, trade, finance and military muscle, but vital supporting roles were played by history and religion. After decades of Hanoverian, i.e. European rule, Victoria was perceived as a British monarch. Similarly, Gothic was perceived as a British style, independent of European classicism. Gothic was broadly drawn and came to mean medieval, Tudor and Jacobean, and in its application fact and fantasy were indivisibly intermingled. Parallels between Tudor and Victorian Britain were, in any case, frequently drawn and seemed particularly relevant for a nation that was rapidly creating the greatest trading empire the world had ever known. Gothic, as a colourful and dynamic style, as a new morality, as a force for political independence, as a vehicle for social change and as a reflection of a glorious past – more fantasy than fact – took the nation by storm.

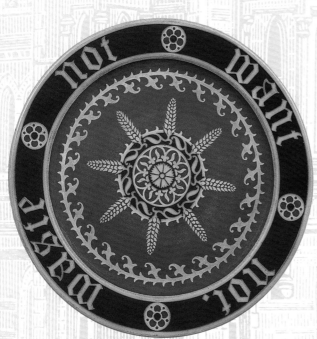

9 (left). August Welby Northmore Pugin, bread plate. Earthenware, manufactured by Minton, 1851. V&A: C.46-1972. Pugin, in many ways the world's first industrial designer, was driven by his belief in the suitability of the Gothic style for the New Britain he was helping to create. His love of colour and pattern, his fascination with new technology and his firm sense of morality are all reflected in the famous 'Waste Not Want Not' bread plate he designed for the potter Herbert Minton.

10 (right). Sir Edwin Landseer, *The Bal Costumé* (detail). Oil on canvas, 1842. The Royal Collection © HM Queen Elizabeth II. A love of pageantry combined with a free and imaginative interpretation of history inspired countless costume balls and theatrical events, all of which helped to establish the necessary historical background for Victoria's New Britain. In this painting Landseer depicts Victoria and Albert as they appeared once at a costume ball, dressed as Edward III and Queen Philippa, monarchs from what was then perceived to be a great period in English history.

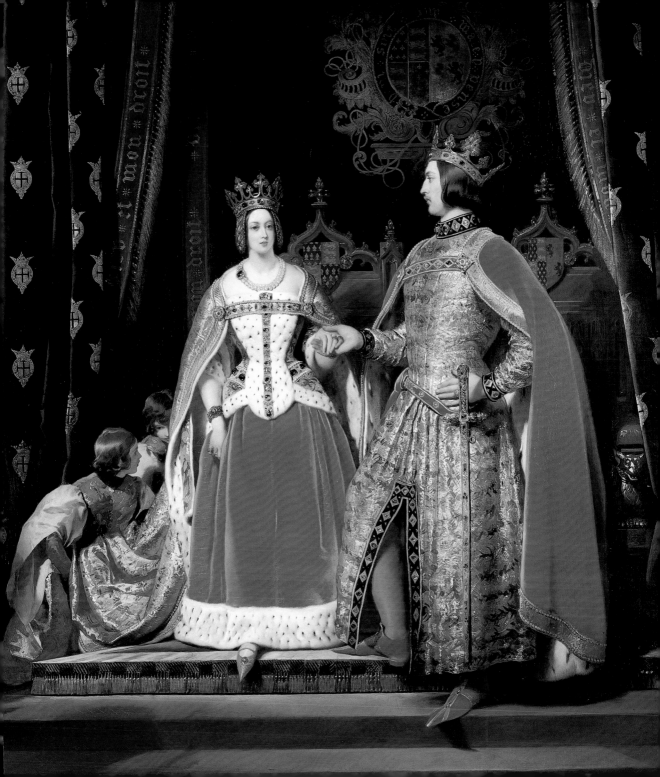

11. John Anderson, *Westminster Bridge, the Houses of Parliament and Westminster Abbey seen from the River*. Oil on canvas, 1872. Museum of London.

The destruction by fire of the old medieval Palace of Westminster in October 1834 marked the point of change between the old order and the emergent New Britain. The government commission set up to organise an architectural competition for the new Palace of Westminster decreed that the building had to be in the Gothic style, closing the door firmly on the old traditions of European Classicism. The competition was won by Charles Barry, aided by the young Pugin, and the building they created redefined British democracy and the British parliamentary system by formalising the relationship between monarch, church and government.

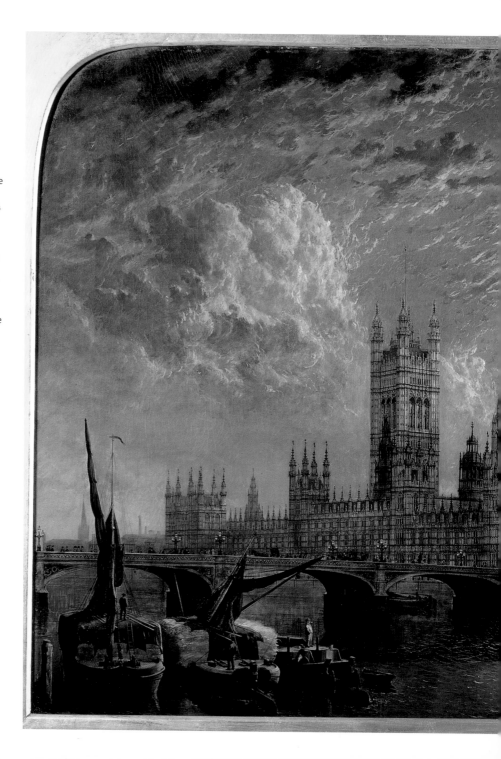

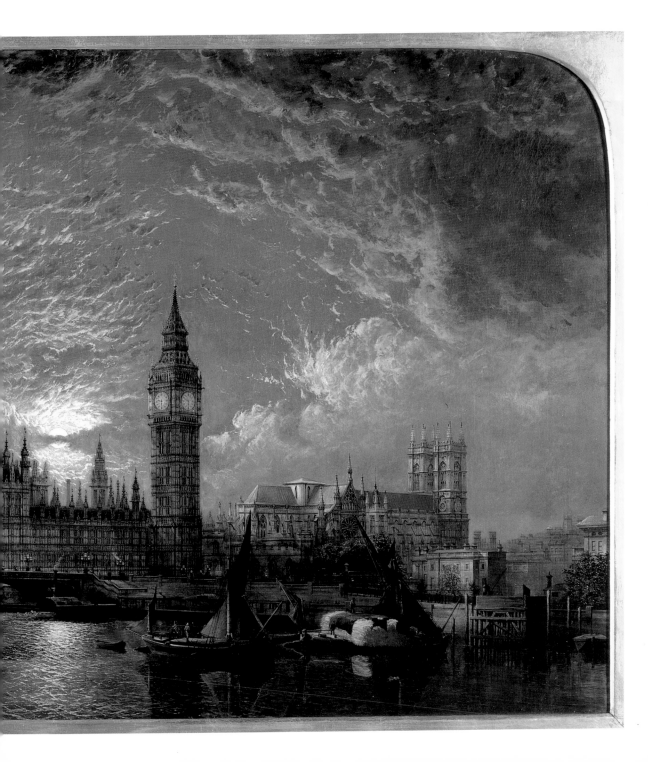

VISIONS OF THE NEW BRITAIN

GREAT EXHIBITIONS

The opening by the Queen of the Great Exhibition of the Art and Industry of All Nations in May 1851 was a defining moment in Victorian Britain. Housed in a building that was itself a triumph of modern technology, the exhibition presented to the public a new view of the world, seen through manufactured goods and indigenous products. At the same time, it reaffirmed Britain as a trading nation of enormous power and influence. By its nature, the exhibition was also about taste, its contents indicating clearly that choice and consumption were vital components of the New Britain. Enormously successful, the exhibition attracted over 6 million visitors between May and October 1851, and the profits generated were used to create a cultural centre in South Kensington. Its most important legacy, however, was to provoke other international exhibitions across the world to promote trade, culture and manufactured goods.

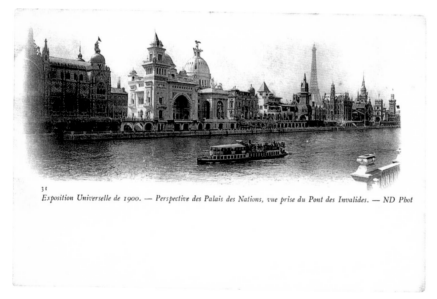

Exposition Universelle de 1900. — Perspective des Palais des Nations, vue prise du Pont des Invalides. — ND Phot

12. Postcard from the Exposition Universelle, Paris 1900. After 1851, international exhibitions and trade displays were organised almost on a yearly basis throughout the remainder of Victoria's reign, with the most influential being held in Paris, London, Vienna, Philadelphia, Melbourne and Chicago. In 1900 the exhibition held in Paris established the styles and attitudes for the new century and underlined in its dynamism and diversity the legacy of 1851.

13 (right). *Interior of the Crystal Palace.* Watercolour, c. 1851. V&A: AL8270. The scale of Joseph Paxton's revolutionary building and the delicacy and clarity of its iron and glass architecture was balanced by the colourful diversity of the displays, arranged predominantly by material and country of origin. New technology was a powerful theme throughout the exhibition.

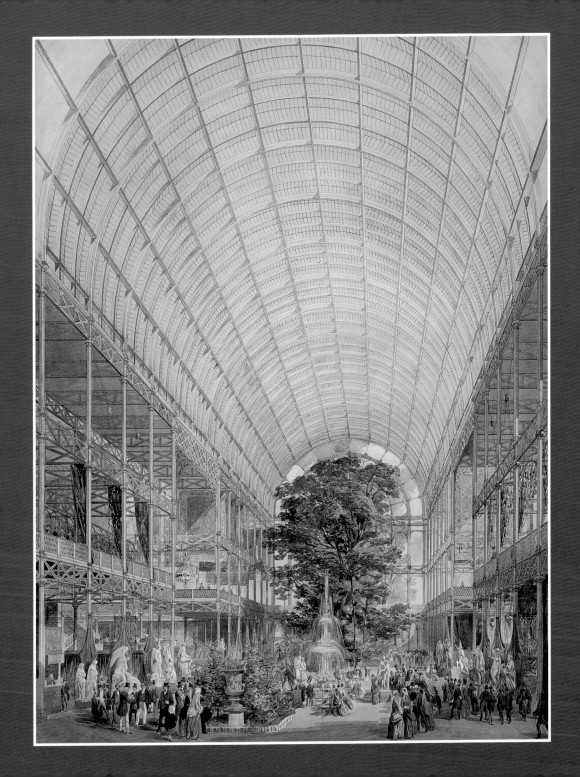

THE SEASIDE

Although the taste for sea bathing had been established in the late eighteenth century, it remained a minority and rather exclusive activity until Victoria came to the throne. By the early 1850s enthusiasm for the seaside was universal, generated by royal taste and speedier access via train or steamship. Seaside visits were also greatly encouraged by the Bank Holiday Act of 1871 and by subsequent legislation that made paid holidays compulsory.

The Queen and her family regularly visited the seaside and were instrumental in establishing several resorts, notably the town of Ramsgate in Kent and, of course, the Isle of Wight. In many ways the Isle of Wight was entirely a Victorian creation, following the building of the royal palace at Osborne, and it remained a microcosm of the society that had created it.

Railway companies not only facilitated travel to the seaside but were also directly involved in the development of resorts all around the coasts of Britain. From an early date seaside visiting became a classless activity, and this in turn generated a huge demand for hotels and boarding houses, restaurants, souvenirs and entertainment. Important legacies of this time include the pier and the postcard. The pier, initially an extended landing stage for steamers, became the focal point for seaside celebration, complete with food stalls and restaurants, theatres, funfairs, mechanical peepshows, slot machines and other entertainments.

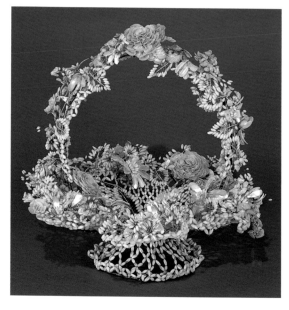

14 (above). Shell basket, mid-19th century.
V&A: AP.51-1862.
Initially reflective of local traditions, and using local materials such as shells and sand, the seaside souvenir business developed rapidly from the 1850s. The making of pottery, glassware and metal and wood products featuring maritime motifs and the names of the resorts became a major business that towards the end of the century was increasingly dominated by European suppliers.

15 (right). William Powell Frith, *Life at the Seaside (Ramsgate Sands)* Detail. Oil on canvas, 1854. The Royal Collection © HM Queen Elizabeth II.
Before Osborne was built, the royal family were regular visitors to Ramsgate, and it was this royal presence that turned the Kentish port into the fashionable resort depicted by Frith. In its crowded diversity and wealth of detail, the painting underlines the egalitarian nature of the British seaside and offers an enduring insight into social habits, costume and entertainment.

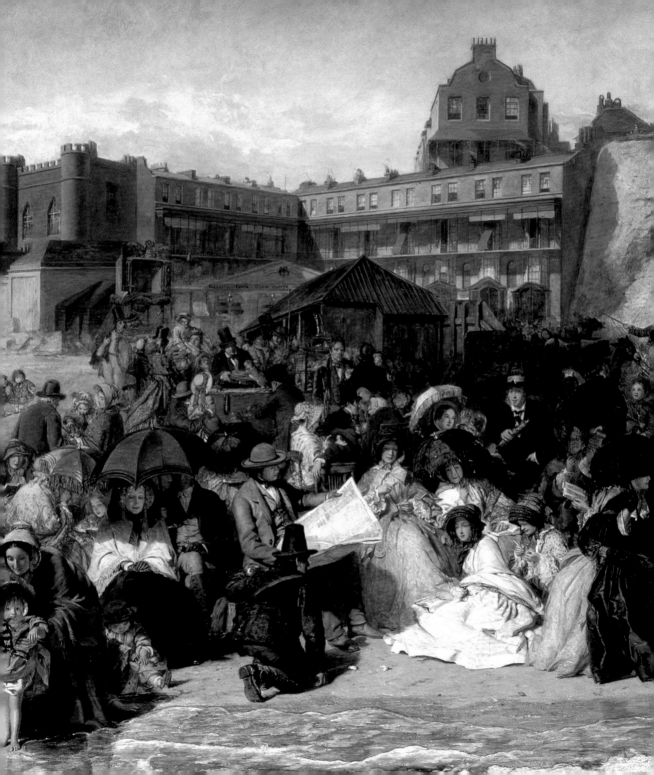

SPORT

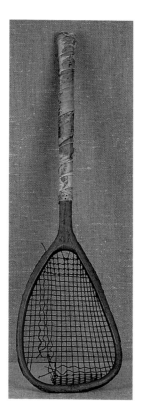

The principles and rules governing many modern team and individual sports – including cricket, football, rugby, tennis, boxing and athletics – were laid down by the Victorians. The first tour to Australia by English cricketers was in 1877. The county cricket championship dates from 1889. The Football Association was founded in 1863 and the FA Cup was inaugurated in 1872. The Rugby Football Union was founded in 1871, the Wimbledon All England Lawn Tennis Championship began in 1877 and the Queensberry rules for boxing were laid down in 1867. The first modern athletics meeting seems to have been held at the Royal Military Academy, Woolwich, in 1849, paving the way for the revival of the Olympic Games in 1896. Equally important was the public enthusiasm for modern sports that turned spectating into a major leisure activity. The appetite for sporting events was insatiable, along with the interest in sporting heroes. Captain Matthew Webb, the first man to swim the English Channel in 1875, was lionised, as were the jockey Fred Archer and the cricketer, Dr W.G. Grace. The popularity of these sports encouraged the public to take up tennis, croquet, boating and, above all else, cycling during the last decades of the century.

16. Sphairiftke tennis racquet, 1874. Wimbledon Lawn Tennis Museum. Modern lawn tennis was developed in the 1860s and as an amateur game it quickly became a popular leisure activity, enjoyed in schools and among families as it could be played by women and children. After the success of the first Wimbledon championships, the game enjoyed a high profile. The racquets and rubber balls used were progressively developed, laying down the foundations of modern high-tech equipment.

17 (right). *Premier Bicycles.* Poster, *c.* 1900. V&A: E.14436-1919. The popularity of cycling was reflected by the great variety of bicycle images that appeared in cartoons and decorative advertising posters towards the end of the century. Following the development of the modern safety bicycle in the 1870s, cycling became a universal activity, notably egalitarian and open to both sexes.

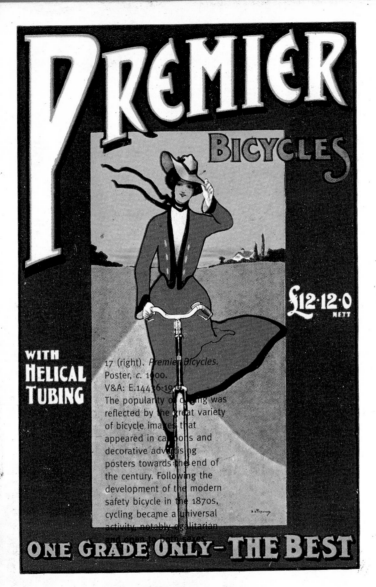

17 (right). *Premier Bicycles*.
Poster, c. 1900.
V&A: E.14436-19...
The popularity of cycling was
reflected by the great variety
of bicycle images that
appeared in cartoons and
decorative advertising
posters towards the end of
the century. Following the
development of the modern
safety bicycle in the 1870s,
cycling became a universal
activity, notably egalitarian
and open to both sexes.

THE CELTIC REVIVAL

The Victorians played a major role in the revival of all aspects of Scottish culture, and the establishment of Scotland as a focus for fashionable taste naturally followed the acquisition of the Balmoral estate by the royal family from 1848. The most visible aspect of this was the revival of the tartan, both as the symbol of the clans and as a decorative accessory whose style reflected current enthusiasms for colour and pattern.

Travel to and within Scotland was made easier by the expanding network of railways and shipping lines, and the development of Scottish resorts quickly followed. This led to a widespread interest in all aspects of Scottish culture, including language and literature, music and dancing, costume and folk traditions, hunting, fishing and Highland sports, food and drink. It should not be forgotten, however, that this was also the time of the Highland clearances – evictions that eliminated the majority of the Gaelic-speaking population – which only ended in 1886 by the granting of security of tenure to the crofters. By the last decades of the century the interest in Scotland had broadened into an enthusiasm for all things Celtic. Ireland and Wales experienced a similar cultural reawakening, with echoes in Cornwall and the Isle of Man. By the 1890s the Celtic style was appreciated far beyond the shores of Britain, to the point that it became one of the founding forms for Art Nouveau.

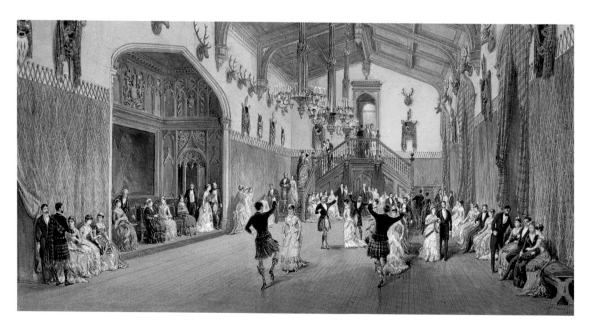

18 (left). W. Simpson,
Ballroom at Balmoral.
Watercolour, 1882. The Royal
Collection © HM Queen
Elizabeth II.
Balmoral was Victoria's
favourite house and, as
such, became the focal point
for fashionable Scottish
taste. It was here that she
wrote much of her best-
selling book, *Leaves from
the Journal of Our Life in the
Highlands* (1869), and it was
to Balmoral that she
withdrew after Albert's
death, ultimately to be
restored there by her
friendship with John Brown,
her Scottish manservant.

19 (right). Tara brooch.
Gold, amethyst and pearls,
1850–1. V&A: 920-1852.
For much of the 19th century
Ireland was overlaid by the
spectres of religious turmoil,
absentee landlords, famine,
emigration and the battle for
home rule. The fight for Irish
independence provoked a
revival of interest in Irish
culture, marked by the
emergence of a new
generation of Irish writers
and painters and by a new
enthusiasm for Ireland's
Celtic traditions. A popular
expression of this was the
Tara brooch, widely
promoted as a symbol for a
new independent Ireland.

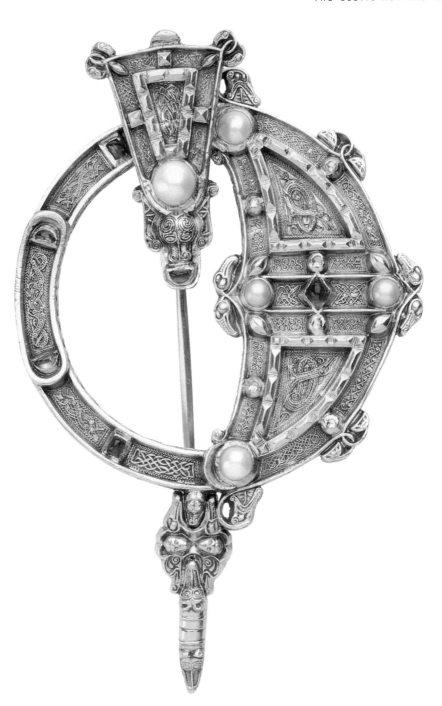

THEATRE AND MUSIC-HALL

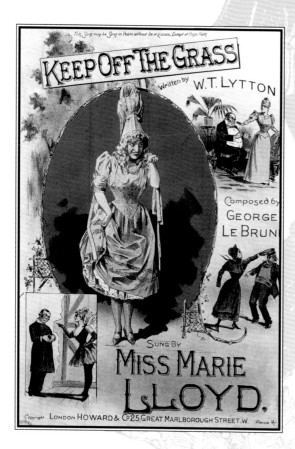

20. 'Keep off the Grass', written by W.T. Lytton and performed by Marie Lloyd. Printed song sheet. V&A: Theatre Museum.

The great music-hall performers, Marie Lloyd, Lottie Collins, Little Tich and other contemporary giants of vaudeville, were in effect national heroes and heroines, and their association with a particular act or song gave them both familiarity and status. This fame was increased by the publishing of popular songs as sheet music with decorative covers featuring the singer's name

The expansion of leisure and the availability of disposable income affected many areas of Victorian social life. Theatre, in all its forms, flourished, and the major performers such as Dame Ellen Terry and Sir Henry Irving, along with great managers, enjoyed the kind of star status normally associated with the twentieth century. Dramatic performances were extravagant and adventurous in their costumes and settings, and in their use of complex stage machinery, special effects and live animals. Opera and ballet were also popular, including comic opera, which was brought to a high point of development by Gilbert and Sullivan. Other types of theatrical entertainment, such as the pantomime, the pageant and the circus, were also hugely successful.

Reflective of class distinctions within Victorian society, theatre was expensive and exclusive. The working-class equivalent was the music-hall, a robust entertainment that served a lively mixture of music and comedy, supported by facilities for eating and drinking. The first music-halls opened in the 1830s and the form then spread rapidly until 1878, when new safety laws forced the closure of smaller halls. Those that survived – large, well-equipped and offering spectacular performances – had a broad appeal that transcended traditional class barriers, with many music-hall artists enjoying great fame and fortune. At the end of the nineteenth century the cinema made a tentative appearance, initially as part of the music-hall experience.

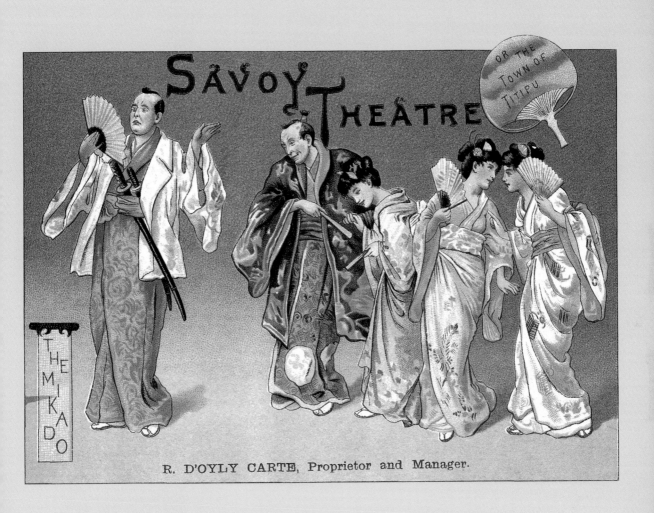

21. Poster for *The Mikado*. 1885. V&A: Theatre Museum. *The Mikado* was one of the most successful of the 'Savoy Operas'. Its zany half-Chinese, half-Japanese orientalism, its sharp satire and its catchy tunes reflected the popular taste of the day. This style of musical comedy, developed with such skill by Gilbert and Sullivan, laid the foundations for a new theatrical form that was to enjoy enormous success in the 20th century in the shape of the musical.

TRAINS

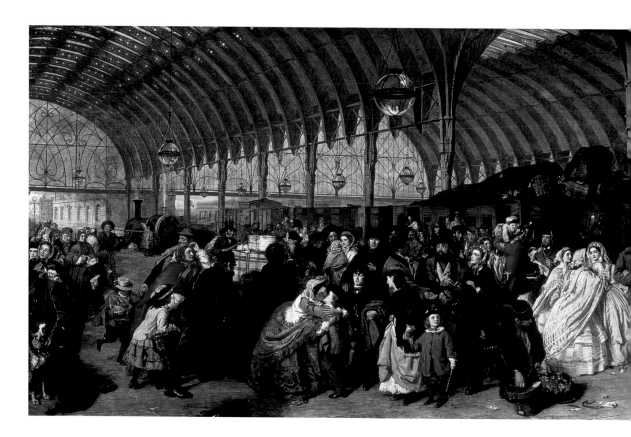

The greatest engine of social change in the Victorian period was the railway. The early years of Victoria's reign coincided with the completion of the major trunk routes – London to Birmingham (1838), London to Southampton (1840), London to Bristol (1841) and London to Glasgow (1848) – and by the early 1850s the railway network had connected most major British cities and industrial regions. Throughout Victoria's reign expansion continued and by 1900 a network that totalled over 18,500 miles (30,000 km) made accessible almost every corner of Britain and carried over a thousand million passengers per year.

Even more important was the carriage of freight, the real financial drive behind the building of railways around the world, and the facilitator for a massive increase in trade. Similar railway networks opened up

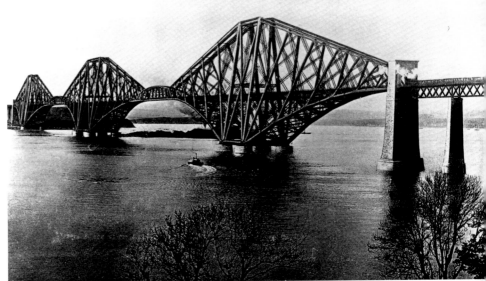

22 (left). William Powell Frith, *The Railway Station*. Oil on canvas, 1862. Royal Holloway and Bedford New College.

In his panorama of Paddington Station, Frith constructed a scene as complex as a Dickens novel to indicate the radical changes imposed on British society by the railway. It was a vision of a new world. Frith's concern was with society, while other artists responded to the train itself, the passengers, the process of travel, the landscape or, as in the case of Turner, the new sensation of speed.

23 (above). *The Forth Bridge*. Photograph, *c*.1900. Science Museum, London / Science and Society Picture Library. When it was opened by the Prince of Wales on 4 March 1890, the Forth Bridge was considered to be a triumph of new technology and a wonder of the world. Designed by Sir John Fowler and Sir Benjamin Baker, the steel bridge was a prime example of pure engineering science that was widely copied and laid down the foundations for 20th-century structural engineering.

Europe, the Middle East, the Americas, India, Africa and Australia, and these were often built by British finance and British engineering and manufacturing skills. The building of railways around the world made a lasting impact on the landscape, and the bridges, tunnels, embankments and other features created by the great engineers underlined the power of Victorian ambition and ingenuity.

SHIPS AND COMMUNICATIONS

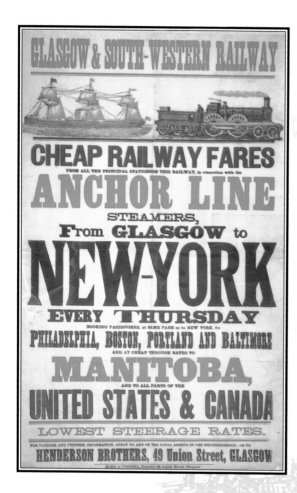

As a trading nation with an expanding empire, Britain needed efficient and reliable communication and transport networks. Railways played their part, but ultimately as important was the electric telegraph, patented by Sir William Cooke and Sir Charles Wheatstone in 1837 as the basis for railway signalling. By 1851 there was a cable link under the English Channel, by 1866 a successful transatlantic cable was in place and by the 1870s there were both overland and undersea links between Britain and India.

The real key to Britain's imperial success was the rapid development of the modern steamship, which ensured that Britain could dominate the trade routes of the world and guard their security with a huge up-to-date navy. Through the use of iron construction, advanced steam engines and propeller propulsion – first used in 1839 and improved by Brunel, among others, during the 1840s and 1850s – ships grew larger and more efficient and journey times shrank accordingly. By 1855 the transatlantic passage had been reduced to nine days and after the opening of the Suez Canal in 1869 London to Bombay took 15 days. Larger ships also meant greater comfort and by the 1880s passenger ships had come to resemble floating hotels. Britain not only dominated the sea routes throughout much of Victoria's reign but was also the world's leading shipbuilding nation.

24. Emigration poster promoting the Anchor Line's cheap passages from Glasgow to the United States and Canada. Late 19th century. © Scottish Record Office.

Throughout Victoria's reign, millions of her subjects emigrated from Britain in the hope of finding a better life overseas. Most came from Ireland and Scotland, driven out by economic hardship caused by famine, clearances and other social disasters. Between 1850 and 1900 over 10 million people left Britain, mostly for the USA, but also for Canada and Australia. Many shipping companies specialised in the supply of cheap passages, but even the grandest ships also carried emigrants.

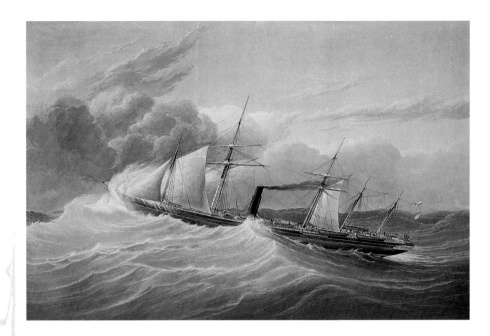

25 (left). Joseph Walter, *SS 'Great Britain'*. Lithograph, 1843. Science Museum, London / Science and Society Picture Library. Built in 1843 to the designs of the brilliant engineer, Isambard Kingdom Brunel, the *Great Britain* was the world's first practical screw-driven iron steamship. She carried 360 passengers in reasonable comfort and could cross the Atlantic in 15 days.

26 (right). *Sunday morning muster in the Indian Ocean.* Watercolour published in W. W. Lloyd's *P&O Pencillings* (1890).

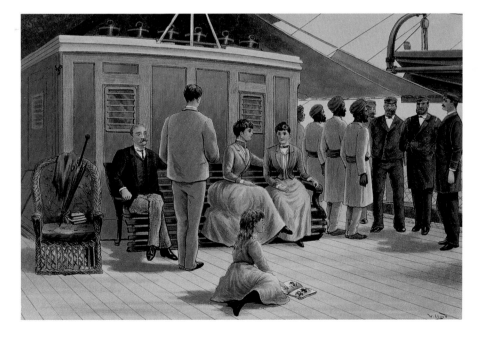

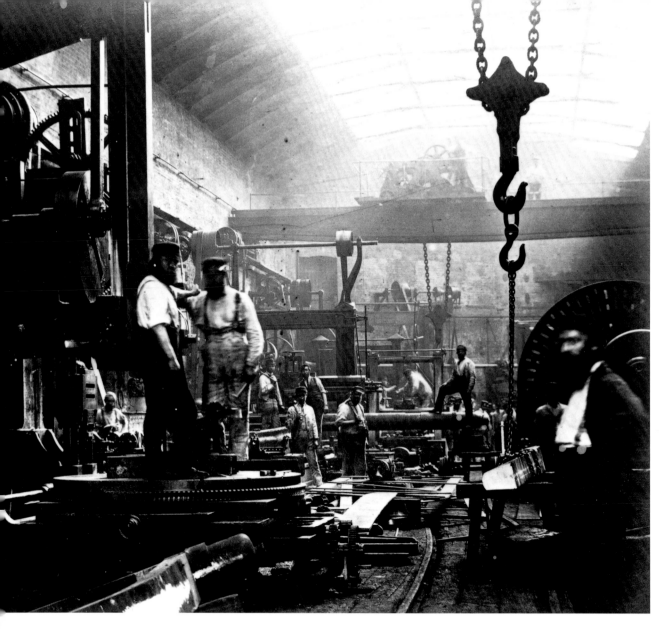

27 (above). *Thames Ironworks*. Photograph, 1867. Hulton Getty Picture Archive. The desire to depict the realities of industrial and agricultural life was an increasing concern from the 1860s among photographers who, by the immediacy of their medium, were less dependent than artists and writers upon conventions of social analysis and narrative structure. This photograph is a reminder that Victorian industry and imperial wealth were built upon the power of coal, iron and engineering.

28 (right). Hubert Herkomer, *On Strike*. Oil on canvas, 1891. Royal Academy of Arts, London.
The economic uncertainties of the 1880s that affected much of the western world were matched by the rise of militant trade unionism. The

WORK

At the heart of Victorian society lay the work ethic. Work was essentially honourable, and the rewards for hard work, ambition and enterprise were believed to be wealth, respectability and moral improvement. At the same time, certain types of work carried clear definitions of social level, underlining the principle that men and women knew their place and were content to accept a strictly stratified society, many elements of which were enshrined in law. The philosophy of work was, therefore, a vital component within the structure of Victorian society. As such it attracted writers and artists who saw it as a subject suitably expressive of Victorian society as a whole, and the moral principles upon which it was built. The approach was generally narrative and to some extent idealistic, but towards the end of the century there was an increasing fascination with the reality of work and its social impact. The phenomenon of social realism became an important force among artists and writers throughout Europe and the western world from the late 1870s, fired by new concerns about the actualities of industrial and agricultural work, the impact of unemployment and economic decline, and the need to take a more analytical attitude to society. Equally important was the contemporary rise of the trade unions. In Britain union membership rose from 250,000 in 1869 to over two million in 1900.

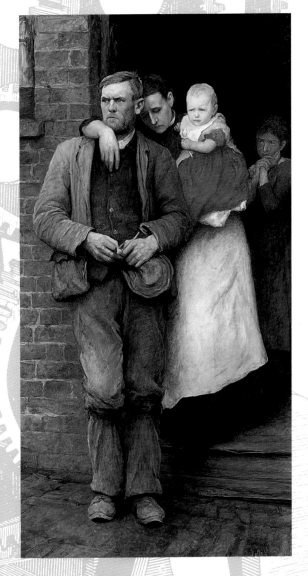

first Trades Union Congress was held in 1868 when 34 delegates represented 118,367 members. By 1890, following the successful dock strike of the previous year, the figures were 457 and 1,470,191. This painting is a reminder of both the emergent power of the strike weapon in late Victorian Britain and the hardships that were the direct result of industrial unrest.

The Urban Scene

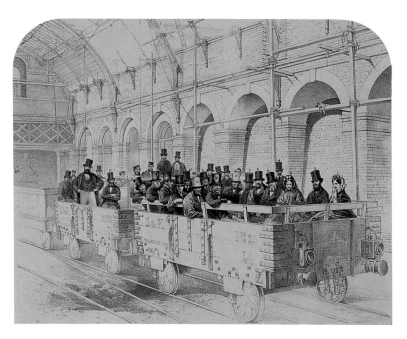

The modern city is probably the greatest, and the most lasting, of Victorian creations. Ever expanding in response to the needs of trade and productivity, the Victorian city witnessed the development of industrial housing, high-rise architecture, factory estates and, ultimately, the suburbs. For those able to escape the smoke-filled skies and grimy streets, the attraction of working in a city and living on its rural extremities became a major concern during the last decades of Victoria's reign, establishing in the process the habit of commuting. The natural conclusion of the continuing pursuit of the rural fantasy of suburban life, and the resultant exploitation of outer city greenfield sites, was the concept of the garden city, a favourite late Victorian conceit imported from the USA.

The spread of the suburbs, equally relentless in its own way, was made possible by the development during Victoria's reign of practical systems of well-integrated urban public transport. The horse-drawn bus, which had been used in a limited way in the pre-Victorian era, was the ideal vehicle, along with the horse-drawn cab, for the rapidly expanding transport networks being developed in many towns and cities. Next came horse-drawn trams, first used in Britain in Birkenhead in 1860, followed in the 1870s by the more limited steam-hauled trams. The real breakthrough came with the first British electric tram networks, in operation in Blackpool from 1884, and Leeds from 1891. Even more important was the rapid development of suburban rail services, a feature of most large industrial cities from the 1860s. In London, there was also the underground railway. The first route, opened in 1863, became the basis of an expanding network that served both the city and its outlying suburbs. At the end of the nineteenth century, smaller underground networks were also in operation in the Liverpool region and in Glasgow.

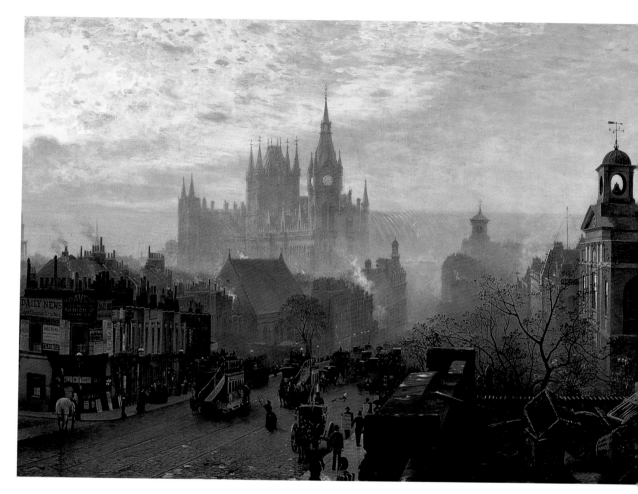

29 (left). The Opening of the
Metropolitan Railway.
Engraving from *Illustrated
London News*, 1863.
City of Westminster.
The world's first
underground railway, the
steam-hauled Metropolitan,
was opened in London
between Paddington and
Faringdon Street in 1863.
This line, and its subsequent
extensions, was excavated
from street level, on the cut
and cover system. The next
generation of underground

lines, the deep-bored tubes
designed for electric traction
and served by hydraulic lifts
from street level, was
opened from 1890.

30 (above). John O'Connor,
*Pentonville Road Looking
West.* Oil on canvas, 1884.
Museum of London.
This painting, which shows
an evocative view down
London's Pentonville Road
towards the Gothic towers
and spires of Sir George
Gilbert Scott's Midland

Grand Hotel at St Pancras
station, is one of the great
images of Victorian urban
life. Not only does it show
the massive scale of the
hotel, but it also illustrates
various forms of urban
public transport, including
cabs and horse-drawn trams,
along with the paraphernalia
of contemporary advertising.

31 (overleaf). M. Trautshold,
View of Bedford Park.
Lithograph, 1882.
V&A: E.4039-1906.

Bedford Park, one of the
first suburban estates in the
world, was built in west
London from 1876 to the
late 1880s. Architect-
designed by leading figures
such as Edward Godwin,
Norman Shaw and Charles
Voysey, self-contained
and with a degree of
individuality among the
houses, each of which was
set in its own small garden,
the estate was made
practical by its good public
transport connections.

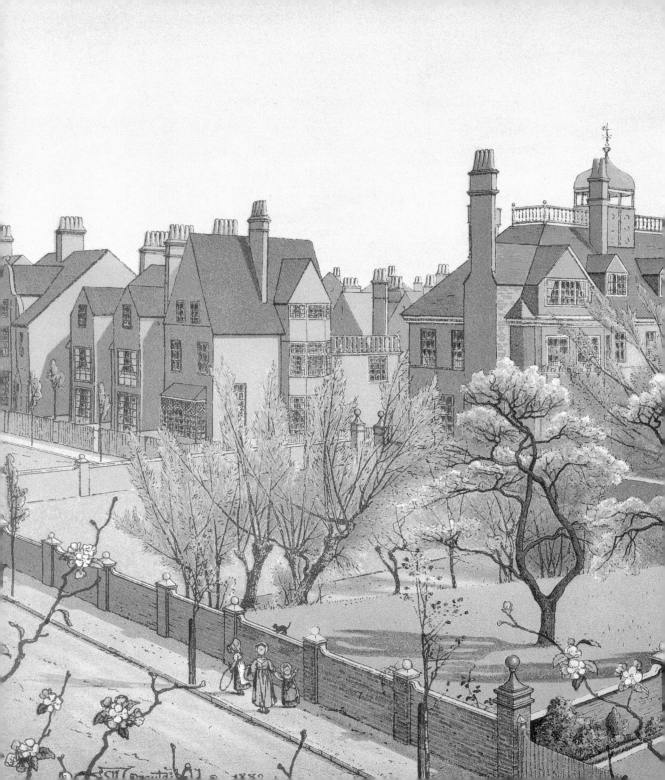

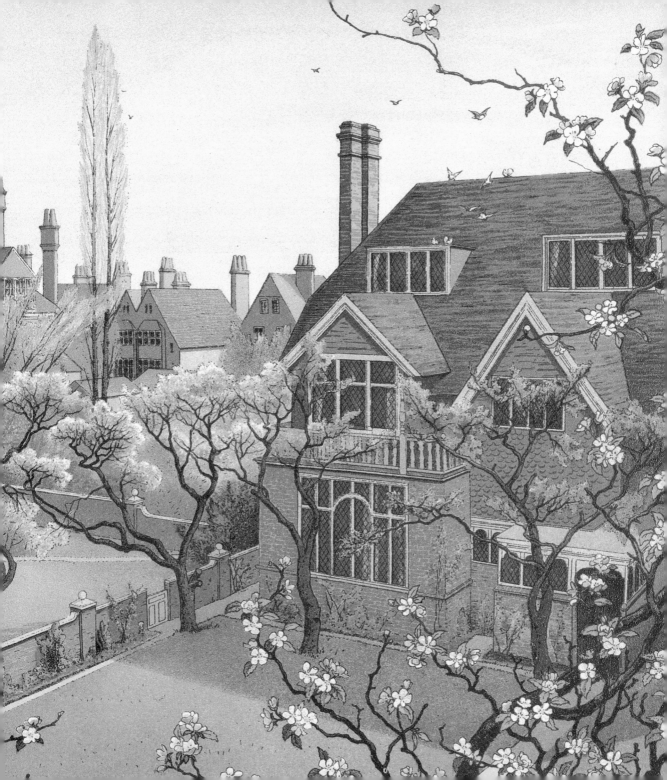

DOMESTIC TECHNOLOGY

In the area of domestic life, the Victorians really were the makers of the modern world. By 1900 a house or office could be equipped with a sewing machine, typewriter, telephone, carpet sweeper, washing machine, mechanical cake mixer and vegetable slicer, pressure cooker, fridge, gas water heater, flushing lavatory, safety razor, vacuum flask and phonograph or gramophone. Outside could be found a bicycle, motor cycle or motor car equipped with pneumatic tyres. However, the real revolution was in the field of electricity. The first town in Britain to have a source of electrical power for public and private use was Godalming in Surrey, from 1881. The idea of electric light had been established by Humphry Davy early in the century, but it took the combined efforts of two rival inventors, Joseph Swan and Thomas Edison, to perfect the light bulb in the late 1870s.

Most middle- and upper-class families in Britain still employed some kind of living-in staff or servants, however, and many traditional domestic chores were still done by hand. The census of 1851 revealed that over a million people were employed in domestic service and this pattern was maintained throughout the century.

The final achievement of the Victorians in the field of science was the effective development, by Guglielmo Marconi, of wireless, patented by him in Britain in June 1896. In 1898 Queen Victoria made a wireless communication from Osborne House to the Prince of Wales who was anchored offshore on the royal yacht.

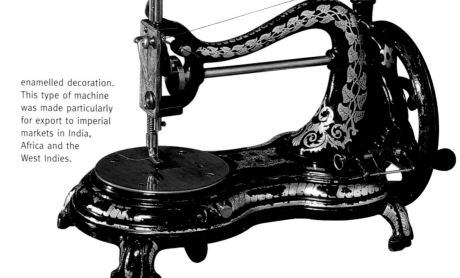

32. Jones lock-stitch sewing machine, c.1890. Science Museum, London / Science and Society Picture Library. During the latter part of the century the sewing machine became widely available, with many makers competing for the ever-expanding domestic market. Typical is this Jones machine of about 1890, whose advanced technology is contained within the standard shape with its characteristic enamelled decoration. This type of machine was made particularly for export to imperial markets in India, Africa and the West Indies.

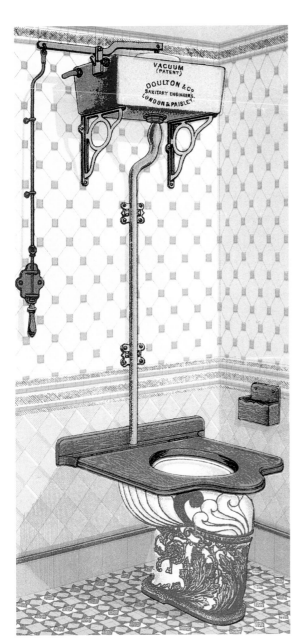

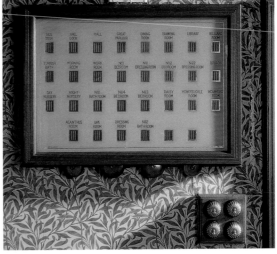

33 (left). Advertisement for Doulton water closet. 19th century. V&A:NAL. During the early part of Victoria's reign, Britain was devastated by a series of cholera and typhoid epidemics, one of which probably caused the death of the Prince Consort in 1861. The resultant concerns about public health and hygiene provoked a nationwide campaign to build modern water supply and sewerage systems for the ever-growing cities. By the 1870s much of the infrastructure was in place and many manufacturers had already entered the sanitary ware business.

34. Electric bellboard. Wightwick Manor, West Midlands, c.1893. National Trust Photographic Library. The application of electric power to domestic houses started in the early 1880s and then spread rapidly as the cleanliness, efficiency and relative simplicity of the technology became apparent. One of the most familiar domestic applications of electrical power was the bellboard, operated by a low current, and indicating that many houses were still dependent upon domestic servants.

ADVERTISING AND SHOPPING

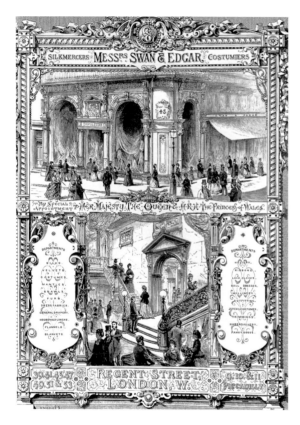

35 (above). Advertisement for Swan & Edgar. Tradecard, 1870. Museum of London. The first department stores in Britain were opened in the 1870s, and many of the great names, including Liberty's, Harrods, Army & Navy and Swan & Edgar, were founded by the turn of the century. The appeal was not just the diversity of displays, but the sense of spectacle and romance that was created by large plate-glass windows and artificial lighting.

The major social change in Victorian Britain was the rise of the middle class and the resultant availability of substantial disposable income linked to a desire to consume. The Victorians were, in effect, the first consumer society and their buying habits were determined by a rapid growth in advertising. The application of new printing technologies from the 1840s encouraged the publication of books, magazines and catalogues, many of which included large numbers of advertisements. The same period saw a huge rise in the habit of fly-posting and other kinds of street advertising. Advertising was also carried by public transport vehicles. Most of this was monochrome, relying for its impact on the size and variety of typefaces and the familiarity of the brand name. During the last decades of the century the use of colour became more widespread, resulting in the rapid development of the graphic poster as the primary tool of the advertising industry. Advertising represented consumer choice, and that in turn was the foundation for the popularity of shopping, as a leisure activity rather than a necessity, in Victorian Britain. Shopping streets, shopping arcades and ultimately the department store brought a new look to Britain at the end of the century.

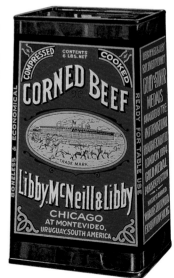

37 (right). After Sir John Everett Millais, *Bubbles*. Colour lithograph, 1886. V&A: E.1660-1931.
The portrait of Millais' grandson painted in 1865 became, through reproduction, one of the most familiar Victorian images of childhood. In 1886 it was bought by Thomas Barratt, the chairman of Pears soap, for advertising purposes. Millais was outraged by the unofficial addition of a bar of Pears soap to the image, but could do nothing about it.

36 (left). Tin of corned beef. Late 19th century. Robert Opie Collection.
The techniques of food preparation and preservation were greatly improved by the Victorians, partly as a result of the need to control disease, and partly as a reflection of increasing British dominance of the food trade in various parts of the world. Notable was British control of much of the South American beef industry, prompting the development, before the availability of refrigerated transport from the 1880s, of modern methods of food processing. A typical creation was corned beef, turned by the Victorians from a novelty into a staple product via the power of advertising.

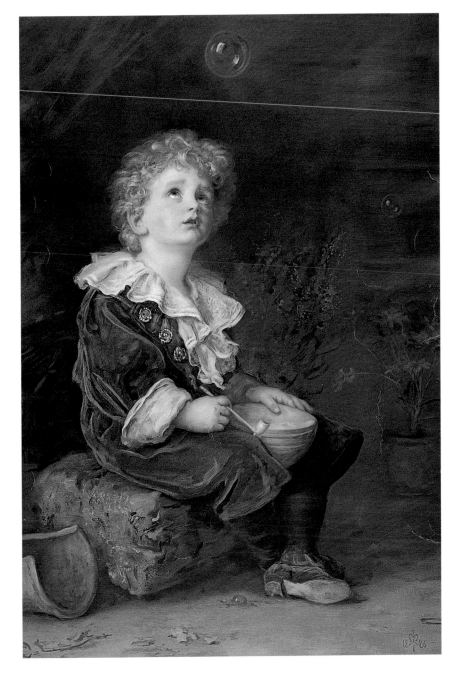

COLOUR

A taste for bright colours in fashion and interior design began to emerge in the 1820s, as part of a general rejection of eighteenth-century neo-Classicism. In the 1830s and 1840s the Gothic revival established the popularity of strong colours and rich patterns, with architects and designers drawing their inspiration from surviving medieval objects such as stained glass, illuminated manuscripts and enamelled metalwork. Another popular source was nature, with many brightly coloured and often exotic plant forms making their way onto textiles and wall coverings, including tiles. Contemporary illustrations of the Great Exhibition of 1851 make it clear that the building, the displays, especially those from exotic countries such as Turkey and India, and the dresses of the visitors were very colourful, despite the continuing dependence upon natural dyes. The Great Exhibition also reflected in its content colours created by new technologies, such as ceramic glazes and chromolithography, or colour printing. In 1856 William Perkin, an 18-year-old chemistry student, discovered mauveine – the first artificial dye colour – and from that point on the dyestuffs industry created quantities of sharp, bright colours that had an immediate impact upon textiles and fashion. By the 1890s, despite attempts by William Morris and other Arts and Crafts designers to return to naturally produced dyes, Britain was awash with colour.

38. 'Latest Paris Fashions'. Plate from *The Queen* magazine (1 July 1893). V&A: E.325-1955.
The popularity of fashion plates, and the new availability of illustrated magazines aimed exclusively at women readers, changed the nature of the fashion industry. Direct effects included the establishment of France as *the* creative centre and a much more rapid change in style from season to season.

39. Owen Jones, Plate IV
from the *Grammar of
Ornament*. Colour lithograph,
1856. V&A: 1577.
First published in 1856, and
made possible by the rich
polychromy of new colour
printing processes, the
Grammar of Ornament was
the finest and most
important of the many style
source books produced
during Victoria's reign. Its
pages, which were filled with
colourful pattern and
ornament drawn from history
and from many exotic
cultures around the world,
were used universally by
architects and designers of
decoration and flat pattern.

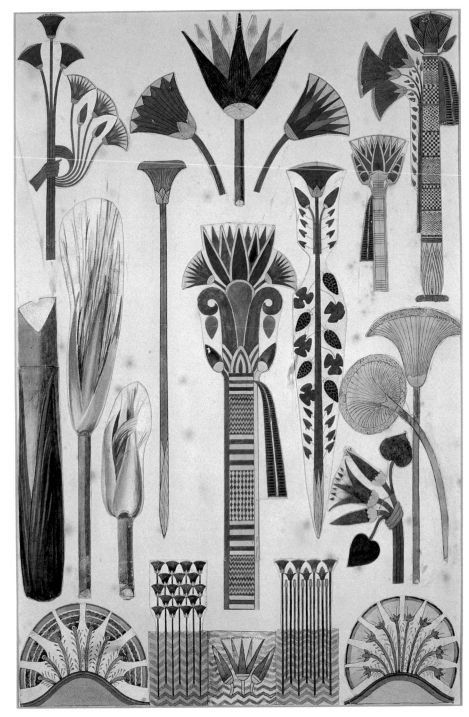

WOMEN

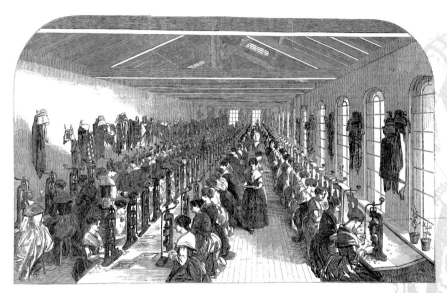

40. *The Slitting Room for Pens.* From *The Illustrated London News* (22 February 1851). V&A: PP.10. Certain manufacturing processes and skills were deemed to be particularly suitable for women – their patience, dexterity and cheapness ensured that large numbers were employed in the pottery industry, in textile production, and in the small metal workshops in the Black Country. Initially excluded from trade union activity, women had, by the end of the century, established their own co-operatives and unions.

Women in Victoria's Britain faced many challenges. As a young mother with nine children and a devoted husband, the Queen seemed to be the embodiment of new family values. At the same time, many of her attitudes revealed a new sense of independence. For example, she was fascinated by the depiction of the female body and collected paintings by William Etty, who was also renowned for his nudes. A fervent supporter of marriage, she was nonetheless aware that in the rapidly changing society of which she was the figurehead, the conventions represented by marriage were under threat as women struggled to maintain their various roles: virgin princess, defenceless mother, plaything and companion,

independent being, temptress and seductress. Despite these conflicting attitudes, government legislation began to underline the principles of female emancipation, notably the series of Married Women's Property Acts. By 1884 a woman was no longer a chattel in law, but an independent and separate person. Emancipation was also encouraged by the opening of modern girls' schools, the admittance of women to universities and to professions such as medicine, and the founding, in 1897, of the National Union of Women's Suffrage Societies. The changing status was also reflected by the increasing importance of women in the workplace, as labourers and, increasingly, as professionals.

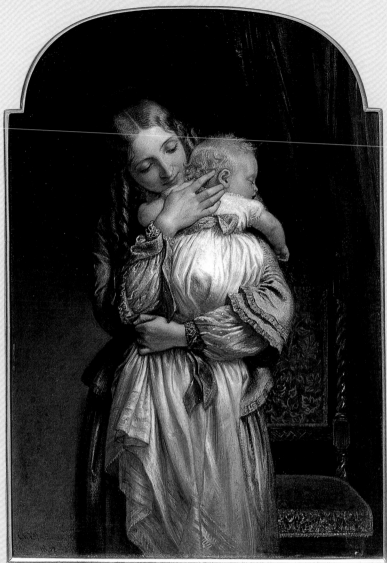

42 (right). After Hiram
Powers, *Greek Slave*.
Replica in Parian
porcelain, 1851. Made by
Minton & Co. V&A:
Circ.90-1968.
The popular sensation
of the Great
Exhibition of 1851,
the *Greek Slave*
was much
reproduced.
A modern
interpretation of
the classical nude,
it managed to
combine concepts
of purity, innocence
and female
perfection with
eroticism, and at
the same time
hinted at the
struggle between
submission and
emancipation.

41 (above). C.W. Cope,
Mother and Child. Oil on
canvas, 1852. V&A: FA 60.
Essentially contemporary in
style and technique, this
painting shows a modern
view of motherhood as a
natural domestic pleasure,
freed from the conventional
Christian imagery of the
Madonna and Child. The
informality echoes the way
Victoria was frequently
depicted with her children.

MEDICINE

The foundations of modern medical practice were laid down by a series of vital discoveries made during Victoria's reign. The first was anaesthesia, developed in the 1840s using ether and then improved by James Young using the preferred chloroform. The second, in 1856, was Louis Pasteur's technique of pasteurisation, which helped to reduce the incidence of tuberculosis. Third was Joseph Lister's experiments with antisepsis from 1865, and the establishment of basic principles of medical hygiene. The fourth was W. K. Roentgen's almost accidental discovery of X-rays in 1895. These major scientific advances were balanced by an enduring fascination throughout the period with the wilder shores of medical practice. There was popular enthusiasm for beliefs such as phrenology, and in the value of electricity as a potent cure-all for both physical and mental problems. Huge fortunes were also generated by the manufacture and sale of patent medicines, for example Holloway's pills.

43. Junker's chloroform inhaler. London, c.1890. Science Museum, London / Science and Society Picture Library.
In 1853, James Young silenced the many critics of the chloroform anaesthetic process by using it to help Queen Victoria with the birth of Prince Leopold. From this point, the more forward-looking medical practitioners encouraged the use of chloroform for childbirth and general surgery, but other more painful methods had not quite died out.

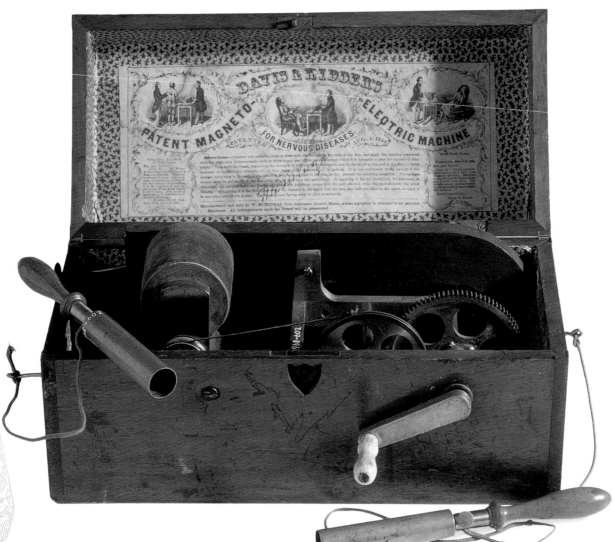

44. Electric shock machine. Late 19th century. Science Museum, London / Science and Society Picture Library. The fascination with electricity as a source of energy and power spilled over into all aspects of Victorian life. In the medical field, connections were established, fanciful or otherwise, between the energy within the human nervous system and external electrical forces. Machines were developed, therefore, that, through the application of controlled electric shocks, stimulated the nervous system in an attempt to cure both physical and mental disorders.

DEATH

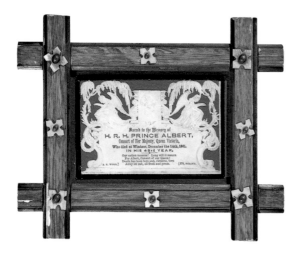

Much of the Victorian preoccupation with death and mourning has been blamed on the Queen's response to her consort's death in 1861, but in fact the subject was one of enduring public interest throughout the period. For much of her reign life expectancy was low, owing to disease and workplace accidents, and the high infant mortality rate ensured that most families frequently experienced death. The application of the death penalty was also quite common and, until the 1840s, public. In 1800 there were 200 offences which could be punished by death but by 1861 the list had been reduced to four.

The Victorians introduced new social codes that formalised the processes of death and mourning, and these provoked a massive expansion of the commercial end of the business, including the profession of undertaking, the making of mourning clothes, the printing of mourning stationery, and the making and selling of all kinds of funerary equipment

from coffin handles to memorial crosses. The high death rate caused overcrowding in established urban burial grounds, threatening public health and hygiene, and so from the 1850s purpose-built necropoli were opened in many parts of Britain. Inspired partly by an increasing familiarity with exotic religions, the Victorians also pioneered the technique of cremation in Britain – the first crematorium was opened in 1885.

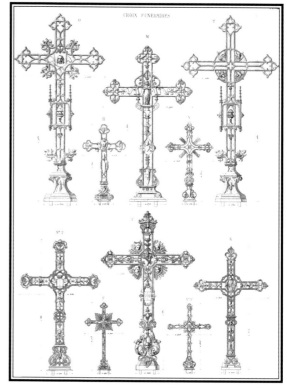

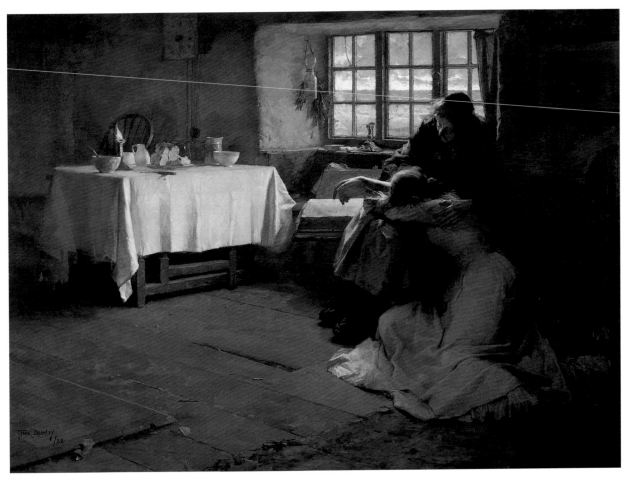

45 (top left). Mourning card.
1861. V&A: E.1508-1903.
The unexpected death of
Albert in 1861 formalised the
process of mourning
throughout the nation.

46 (bottom left). Catalogue
of memorial crosses.
Barbezat & Co., 1858.
V&A: NAL.
The business of death
became an important
commercial enterprise
throughout the Victorian
world. This page from a
catalogue issued by a French
manufacturer in the late

1850s is a typical example,
matching as it does a new
use for cast iron with
modern marketing methods.

47 (above). Frank Bramley,
A Hopeless Dawn. Oil on
canvas, 1888. Tate Gallery,
London.
From the 1880s artists in the
important fishing centres –

the North East, Scotland and
Cornwall – concerned
themselves with the harsh
realities of a way of life that
depended upon the sea, and
on an industry that so often
created young widows and
fatherless children.

RELIGION

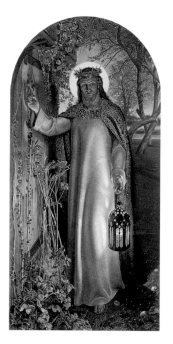

The Victorians were in general fervent supporters of religion and great church builders. From the 1830s there was a revival of both Protestant and Catholic forms of Christianity, matched by a dramatic rise in Nonconformity. By 1875 over 4,500 new churches had been built or rebuilt in Britain and the Christian message was being spread to all the corners of the Empire by missionaries supported by numerous charities.

The religious component in the new British morality was also important, with the emphasis on education, improvement, temperance and philanthropy. In many areas, Nonconformists were prominent leaders of industry. They encouraged trading links among their co-religionists, and promoted the virtues of sobriety and patience in their workforces. Many of the poorest members of society, feeling excluded from the mainstream churches, turned to new religious organisations, such as the Salvation Army, who saw the need to evangelise and provide practical support for the working classes.

In other sections of society, faith was being undermined by recent developments in science and natural history. For some, this led to a renunciation of formal religion, and an increasing interest in the paranormal and psychic phenomena, or in exotic and fringe religions.

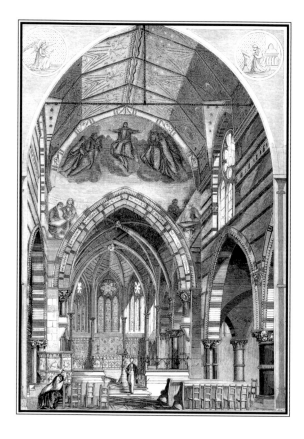

48 (top left). After William
Holman Hunt, *The Light of
the World*. Engraving, 1860.
V&A:E.135-1970.
Hunt's vision of Christ
became the most famous
icon of Victorian Christianity
thanks to the commercial
acumen of the print dealer
Gambart. Engravings of the
picture were sold widely
throughout the Empire, and
several extra versions of the
oil painting were created, to
be toured around Britain and
the colonies.

49 (bottom left). *St James
the Less*, Engraving from
Building News, 2 May 1862.
V&A: PP6.A.

50 (right). George Elgar
Hicks, *A Cloud with a Silver
Lining*. Oil on canvas, 1890.
Forbes Magazine Collection.
The high level of child
mortality provoked a
sentimental vision of death
in which conventional
symbols of Christianity and
the afterlife offered comfort
to the bereaved.

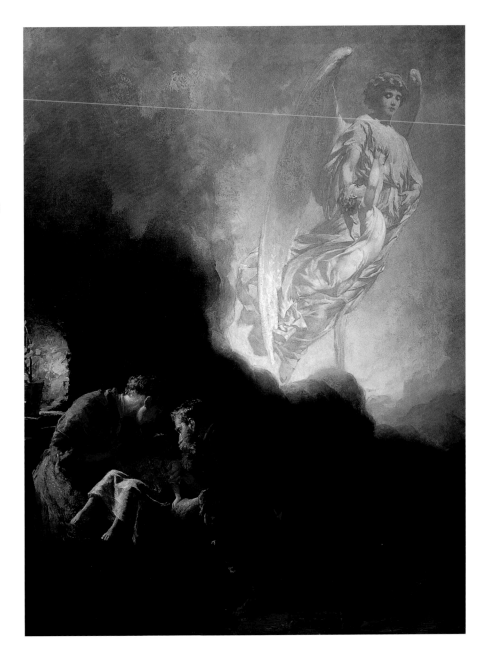

NATURE

DARWIN AND EVOLUTION

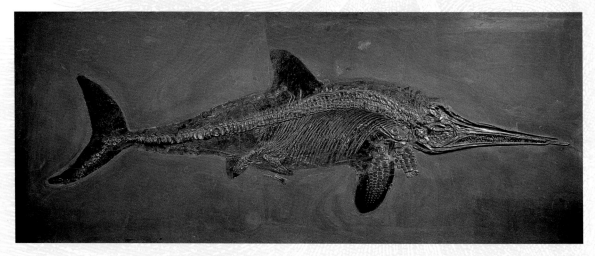

51. *Ichthyosaurus acultirostris*. Marine reptile, *c.*185 million years old. Natural History Museum, London.

This striking fossil was purchased from the palaeontologist Gideon Mantell's own collection in 1853. By the mid-1850s many of the most significant fossil finds had become well publicised, and sculptors were able to produce life-size figures of an iguanodon and a megalosaur for the new Crystal Palace site in South London.

In 1859, Charles Darwin reluctantly published his study of *The Origin of Species by Means of Natural Selection*. He had been working on his theory of evolution for 20 years, but he was aware that his ideas would be controversial as they challenged the biblical timescale of human development. Darwin's theory was reinforced by the discovery of fossil remains, which were catalogued by Gideon Mantell and Mary Anning. The developments that could be charted in fossil samples from different geological layers also suggested that the Earth was much older than the Bible allowed.

Both the problems of pre-history, and the impact of evolutionary theory became topics for popular debate. By 1871, when Darwin published *The Descent of Man*, the focus had increasingly shifted to the relationship between man and apes. If all creatures had evolved slowly from earlier forms, then it was only logical that humans had undergone the same process. The Victorians could no longer rely on the old assumptions that humans were set apart by God and superior to other creatures. Instead they had to consider the suggestion that they were related to the orang-utan, chimpanzee and gorilla.

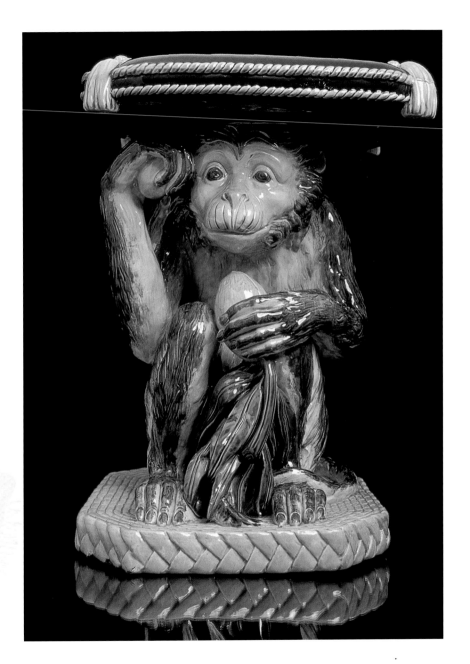

52. Monkey garden seat. Minton, *c.* 1864. Potteries Museum.
Monkeys, apes and men became interchangeable in caricatures, and designers played with the evolutionary debates in their work.

SENTIMENT AND ABUSE

Queen Victoria was very sentimental about her pets, and insisted that her favourite dogs sat for her portrait painter, Sir Edwin Landseer. Prince Albert, too, wanted his dogs to be immortalised; he made small models of his pets, which were then cast in silver and incorporated into a stunning table centrepiece. However, these attitudes were able to sit alongside less sympathetic reactions. The Queen, for example, was delighted by circus acts that used exotic animals.

The Victorian passion for hunting was a more complicated issue. For a start, only the upper classes had access to game preserves, and so the poor were

53. *The Kitten's Wedding.* Late 19th century. Potter's Museum, Jamaica Inn, Cornwall.
The skill of the Victorian taxidermist was most startlingly displayed in Walter Potter's Museum, opened in 1861 at Bramber, Sussex. His tableaux were extremely popular in the second half of Victoria's reign.

54. Frederick Cotman, *One of the Family.* Oil on canvas, 1880. National Museums and Galleries on Merseyside.
Some artists sentimentalised the working relationship between the farmer and his animals. Until the full development of the internal combustion engine at the end of the century, horsepower played a key role in agricultural and urban life.

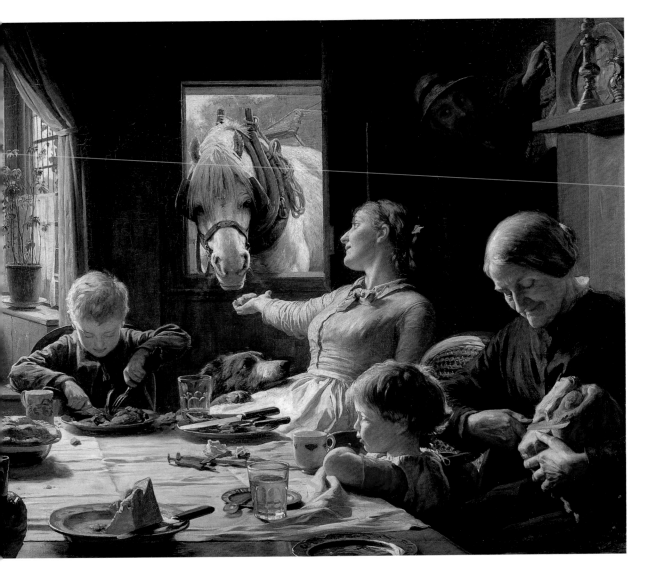

forbidden from taking pheasants, deer or other game for food. In 1803, it had been made a capital offence to resist arrest for poaching, and even at the end of the century there was considerable antagonism between rich and poor over this issue. For the wealthy, hunting was seen as a contest between man and beast. A stag offered a challenge to the intelligence and skill of a huntsman. This was even more true if the prize was a lion or tiger. The ability to make special expeditions to Scotland or Africa also demonstrated the disposable income and leisure of the hunting classes. On their return, they could advertise their success by displaying trophy heads around their homes.

LANDSCAPE

In the mid-nineteenth century, art critics such as Tom Taylor of *The Times* promoted the idea of a distinctively British school of painting. They urged artists to reject overblown historical subjects, influenced by the French, and instead to focus on the best traditions in British paintings. The legacy of John Constable and J.M.W. Turner was invoked to prove that the British were supreme when it came to landscape painting, and to encourage younger artists to follow their example.

John Ruskin threw his weight behind these debates. He, too, praised the art of Turner in his four-volume study of *Modern Painters* (1843). But for Ruskin landscape painting was not just about asserting national identity. Its primary purpose was to demonstrate the hand of God at work in the natural world. Some scenes were more potent than others, and Ruskin was particularly moved by the mountain landscapes of Switzerland: 'The first sight of the Alps had been to me as a direct revelation of the benevolent will in creation'.[1] If landscape paintings were intended to present a religious or moral message, then, to Ruskin's mind, it was essential that artists were true to nature. To ignore or alter God's handiwork was impious. Ruskin made it his business to encourage a group of young British artists, the Pre-Raphaelites, whom he believed were treating nature with the respect it deserved.

56. John Inchbold, *In Early Spring*. Oil on canvas, *c.* 1856. Ashmolean Museum, Oxford.
Some of Ruskin's protégés, including Inchbold, found his expectations too burdensome eventually, and moved away to subjects that required less attention to natural detail.

STYLE AND DECORATION

NATURE AND DECORATION

The Victorian interest in natural history overflowed into their designs for the decorative arts, creating perhaps the most original Victorian style. Often the use of natural ornament was related to the idea of 'fitness for purpose', a criterion put forward by design reformers such as Henry Cole and Richard Redgrave.

Thus a pie dish would be decorated with pottery pigeons in honour of the likely filling. In other cases, real animals would be used for their innate beauty or curiosity. Hummingbirds were a particular favourite, as their iridescent plumage made them ideal costume accessories.

This was just one response to the Victorians' contact with new species. The Zoological and Botanical Gardens which sprang up in Britain and the colonies testified to the excitement that was generated by the continuous expansion of the known natural world. Designers were inspired to reflect this interest in the introduction of new plant and animal forms in their work.

The high-point of this ornate naturalism was the Great Exhibition of 1851, when curvaceous plant forms seemed to engulf every kind of object, from cradles to cutlery. New technologies in metalwork, papier mâché and glass made it easier to create these florid colours and shapes. Some designers in the 1850s and 1860s reacted against this over-abundance, and focused on more controlled use of natural ornament. The lush colours and shapes were tamed, as William Morris and his colleagues imposed discipline on their patterns, and used natural dyes in their textiles.

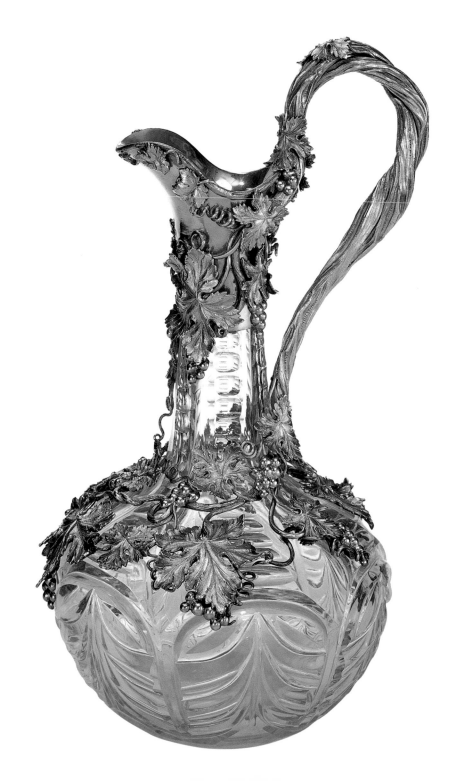

57 (left). 'False Principles'.
Printed cotton textile, 1840s.
V&A: T11.-1933.
The British public reacted
enthusiastically to each new
development, as explorers
brought back samples of
flora and fauna from South
America, Africa, China and
the Pacific. The bold colours
of rhododendrons and the
striking shapes of water-
lilies, recently introduced
into the British landscape,
were incorporated into dress
and upholstery fabrics.

58 (right). Benjamin Smith,
claret jug. Glass and silver,
1841–2. V&A: Circ.117-1962.
Wine decanters were
decorated with silver grapes
and vine leaves, in keeping
with the ideal of appropriate
natural decoration put
forward by design reformers.

HISTORICAL STYLES

Victorian society was in a state of flux. Rapid technological progress led to an equally rapid creation of wealth, with self-made men rising to compete with the established aristocracy. In an age of instability, new men and the old guard both hoped to create a semblance of security by seeking refuge in art and architecture from the past. This tendency to resurrect styles was encouraged by the royal family.

In the mid-century, architects regularly became embroiled in heated arguments to establish the best style for major public commissions. The Palace of Westminster and the University Museum, Oxford were both the subject of controversial decisions to build in the Gothic style. But the example of Classical Greece and Rome also remained popular with designers throughout Victoria's reign. This style was felt to be particularly suitable for large public buildings, as it reflected the dignity and reason of the Classical past. Classical Rome could also be elided with an Italian Renaissance or a Baroque style, which was more colourful and fleshy. The Classical style was popular in northern industrial cities.

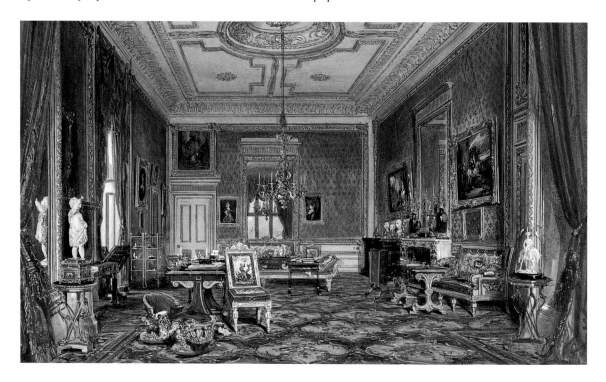

59 (left). Joseph Nash,
*Queen's Sitting Room,
Windsor Castle.* Detail.
Watercolour and
bodycolour, 1846–7.
The Royal Collection
© HM Queen Elizabeth II.
The Queen used both the
Gothic and the French 'Louis'
styles to bolster her
position. The opulent, gilded
French style that was found
throughout Buckingham
Palace and Windsor Castle
allowed the Queen to
demonstrate her wealth.

60 (right). Prometheus vase.
Minton, earthenware, 1867.
Bonhams.
As scholars became
increasingly interested in the
artists of the Early and High
Renaissance, and museums
began to collect 15th- and
16th-century ceramics
and textiles, so designers
incorporated their motifs and
forms into modern work.

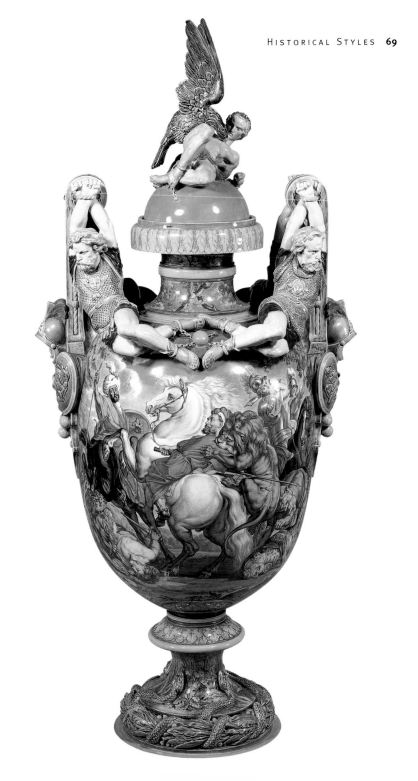

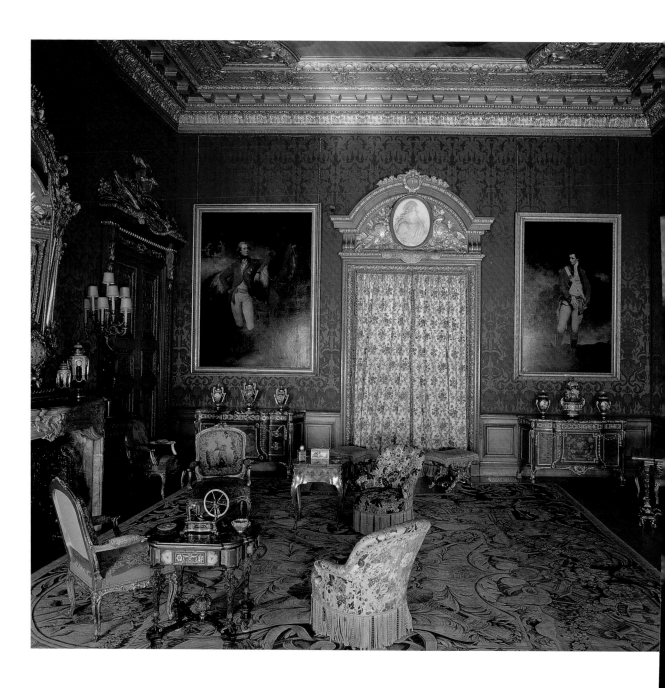

INTERIORS

Although few Victorian consumers could afford it, the rich enjoyed having the interiors of their mansions furnished in a lavish manner. They often encouraged the use of historical references to cover up the recent, industrial origins of much Victorian wealth. By building a house in the country, the newly rich could begin to feel established. William Armstrong, for example, having made a fortune in the arms trade, bought an estate outside Newcastle-upon-Tyne, and commissioned Norman Shaw to build Cragside for him, in a consciously English vernacular style.

Many houses were decorated in a mixture of styles, as certain looks were felt to be particularly appropriate for some rooms, but not for others. So a solid English Renaissance hallway could open into a French Rococo drawing-room. The curvaceous and gilded Louis styles were considered suitable for ladies' rooms, while masculine spaces were decorated in a Baronial or Gothic manner.

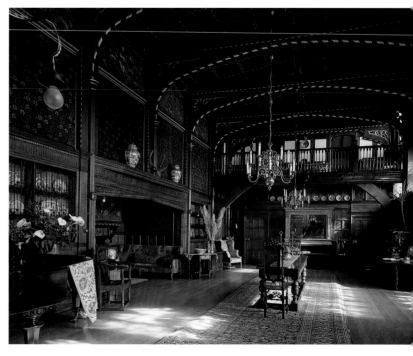

61 (left). Waddesdon Manor, Buckinghamshire. National Trust Photographic Library. The Rothschild family, having made their money as bankers on the continent and in London, displayed their wealth at Waddesdon Manor. The opulent interiors, using antique panelling imported from France, were not to everyone's taste. Gladstone's daughter, Mary, found that she 'felt much oppressed with the extreme gorgeousness and luxury'.[2]

62 (above). The Great Parlour, Wightwick Manor, near Wolverhampton. National Trust Photographic Library. In 1887, Theodore Mander, a wealthy paint and varnish manufacturer, commissioned Edward Ould to design a country house in the popular 'Old English' style. The interiors were furnished from the Morris & Company catalogues and shop. The heavy wood panelling, minstrels' gallery and massive proportions of the great parlour, added in 1893, were intended to reflect the confidence of the Tudor age of British expansion.

JEWELLERY

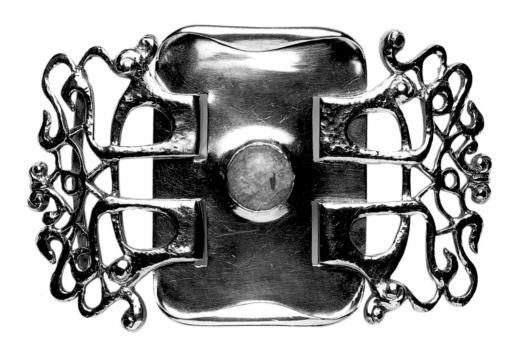

In the Victorian period jewellery came to life as designers and manufacturers moved away from the formality and discreet colours of the late eighteenth century. As in other areas of design, inspiration came from historical reinterpretations of Gothic, the Rococo, Classicism and the Renaissance, and from the natural world.

From the middle of the century there was an increasing interest in more exotic styles, with inspiration coming from India and other parts of Asia, from the Orient and from the Far East. However, even more important for the expansion of the jewellery industry and the exploration of the diversity of sources was the availability of new materials. Imperial growth made accessible to British and European jewellers huge deposits of gold, diamonds, rubies, sapphires and other precious stones, along with new sources of coral, turquoise, pearls, opals and a whole range of other semi-precious gems. Designers and manufacturers also made increasing use of materials not usually associated with jewellery, for example jet and coal, shells, lava stones, porcelain, mosaic, wood and animal and bird parts Towards the end of the century more restrained styles became fashionable again, with the emphasis on silver, enamel and naturally formed semi-precious stones.

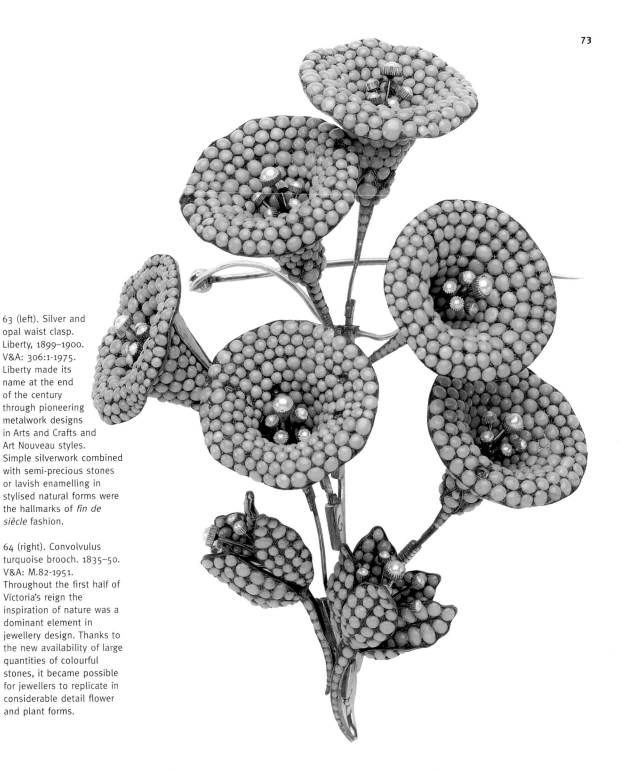

63 (left). Silver and opal waist clasp. Liberty, 1899–1900. V&A: 306:1-1975. Liberty made its name at the end of the century through pioneering metalwork designs in Arts and Crafts and Art Nouveau styles. Simple silverwork combined with semi-precious stones or lavish enamelling in stylised natural forms were the hallmarks of *fin de siècle* fashion.

64 (right). Convolvulus turquoise brooch. 1835–50. V&A: M.82-1951. Throughout the first half of Victoria's reign the inspiration of nature was a dominant element in jewellery design. Thanks to the new availability of large quantities of colourful stones, it became possible for jewellers to replicate in considerable detail flower and plant forms.

ARTS AND CRAFTS

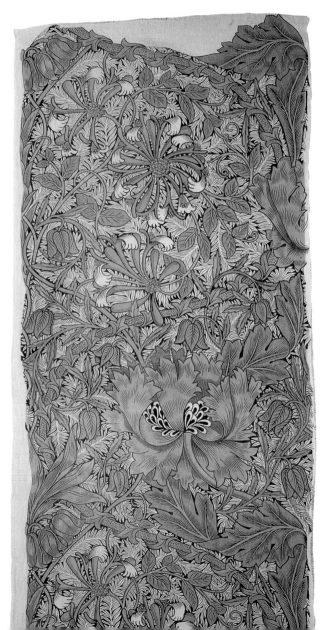

65. William Morris, *Honeysuckle*. Textile, 1876. V&A: Circ.491-1965. William Morris and his partners used British rather than exotic plants to decorate their textiles and wallpapers: pimpernel, honeysuckle and willow replaced hothouse flowers.

All the mainstream Victorian styles relied on ornament that was applied to the surface of complex shapes. These styles were made possible by the new materials and processes that were the pride of British industrialists. However, some artists wanted to take another approach. They made the most of the natural beauty of plain wood, simply constructed furniture and hand-beaten metal.

These Arts and Crafts designers found inspiration from several quarters. Initially, they were reacting against the large-scale factory production of pressed glass, papier mâché and other decorative objects. In William Morris's ideal workshop, the product designer would be prepared to carve wood, print textiles or stain glass. This desire could rarely be fulfilled in practice, but both Morris and Charles Ashbee attempted to train their workforce to take an interest in every stage of production.

Another strong influence came from medieval art. John Ruskin had praised the freedom of the Gothic workman in his study of *The Stones of Venice* (1851–3), and many of his followers were inspired by this vision of expressive carving, leaf and flower forms woven into the fabric of a design, and joyful hand-labour. Ruskin's theories also focused on the need for

66. Charles R. Ashbee, muffin dish. Silver with chrysoprases, 1900. V&A: M.42-1972.
Designers hoped to create simple, well-crafted furnishings to improve the environment of the working man, but the high-quality materials and intensive labour needed to produce Arts and Crafts objects made them far too expensive for the average consumer.

a vernacular style, that sprang out of local conditions, and so encouraged an interest in the continuing traditions of British furniture-making in the provinces.

Inevitably, some commercial manufacturers cashed in on the 'Arts and Crafts' look, by mass-producing metalwork, textiles and furniture that recreated the hand-made appearance and simple decoration of the originals. By the end of the nineteenth century, the 'Artistic Style' was just another option in the department store catalogue.

NEW ART

Most Victorian designers remained aloof from developments on the Continent, but a handful of artists linked up with their more adventurous European colleagues, and in some cases took the lead. The impact of French Impressionist paintings, for example, was felt by Walter Sickert and Wilson Steer who incorporated their innovations in paintings that tackled new subjects such as music-halls and seaside resorts.

Magazines such as *The Studio* also helped to disseminate the radical style of the 1890s, when 'L'Art Nouveau' sprang up across Europe. The Scottish designer Charles Rennie Mackintosh was able to make a distinctive contribution to the new style, as his designs were published widely. He was invited to visit the Vienna Secession in 1900, with his wife Margaret Macdonald. So, during the closing years of the century, British artists at last had a brief encounter with the Continental avant-garde.

67. Charles Rennie Mackintosh, side table from Miss Cranston's tea-room. Oak, painted white, *c.*1899. Glasgow Art Gallery and Museum, Kelvingrove.

Mackintosh's pared down, linear chairs and decorative murals, created for Miss Cranston's Glasgow tea-rooms (1897–1910), were admired by his continental contemporaries.

68 (opposite). Sir James Guthrie, *The Hind's Daughter*. Oil on canvas, 1883. National Gallery of Scotland, Edinburgh. Scottish artists such as Guthrie and John Lavery used French techniques of *plein air* painting and dappled brushstrokes to produce spontaneous and moving pictures of modern life.

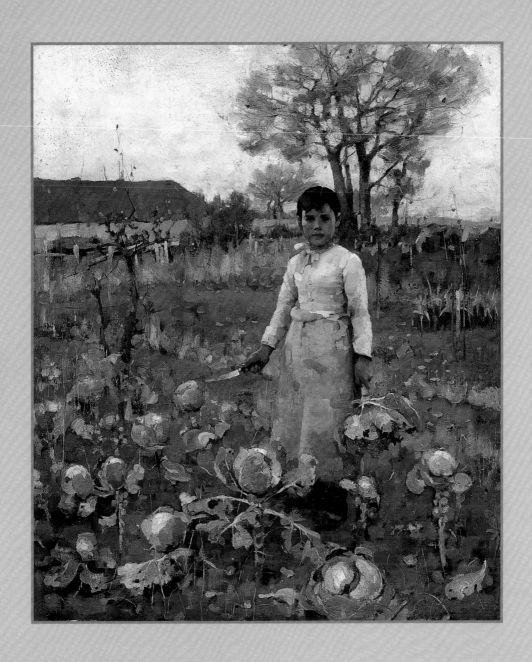

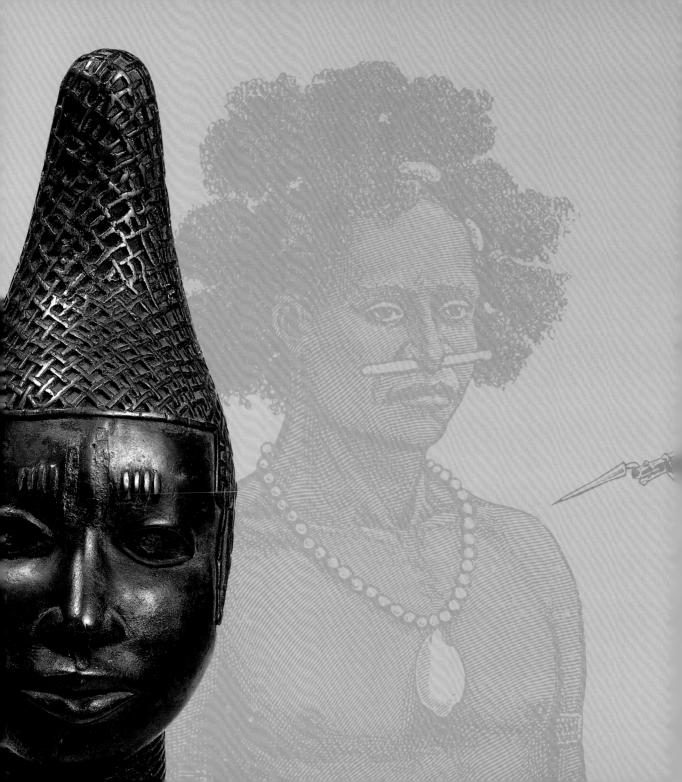

VISIONS OF THE WORLD

THE INFLUENCE OF THE EAST

Throughout the nineteenth century, the Islamic world was looked upon both with fear and fascination. Orientalist painters imagined harem scenes while architects played with ogee arches and intricate carved screens. During the course of Victoria's reign, however, a more accurate and archaeological approach emerged. Artists such as J.F. Lewis and William Holman Hunt spent several years in Egypt and the Holy Land, studying settings for decorative and religious works of art, and David Roberts published his views of the ancient monuments of Egypt, Syria and the Holy Land in a series of magnificent volumes in the 1840s.

Although the interest in the Middle East continued throughout Victoria's reign, attitudes towards the Far East were more variable. The eighteenth-century vogue for chinoiserie continued into Victoria's reign, but from the 1860s this interest was overtaken by an enthusiasm for Japanese art. In 1858, after a century of isolation, the Japanese were forced to sign commercial treaties with Britain and the USA. Japanese goods were then shown to the Victorian public at the International Exhibition of 1862. The quality of the metalwork, prints, textiles and ceramics coming out of Japan at this time seemed to put Britain's own industrial products to shame, and raised the status of the Japanese craft tradition.

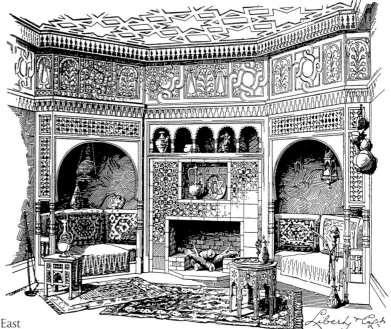

69 (above). Saracen-style smoking room. Plate from the *Liberty Handbook of Sketches*, c.1890. Department stores such as Liberty contributed to a taste for the Orient by importing decorative objects; their small inlaid tables were found in many fashionable houses in Britain.

70 (right). Chinese-style *pâte-sur-pâte* ceramic. Minton, c. 1875. Private Collection. Chinese ceramics had long been cherished by collectors, and continued to exert a strong influence on British manufacturers as they tried to recreate the intricate shapes and glazes.

71. Christopher Dresser, Japanese-style teapot. Electroplate, 1880. V&A: Circ.279-1961.

Some British designers were prepared to travel to Japan to study their production methods at first hand. Christopher Dresser, already one of the most innovative designers of his day, was encouraged by his personal experience of Japan in 1876 to produce dramatic metalware and ceramics for the British market.

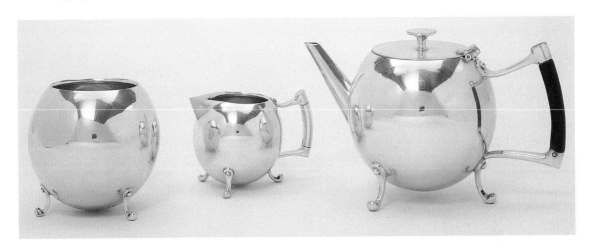

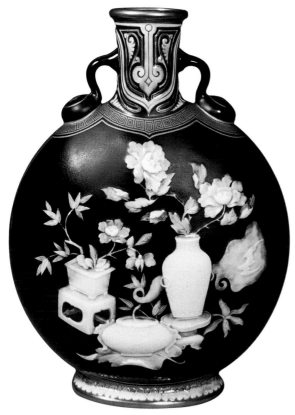

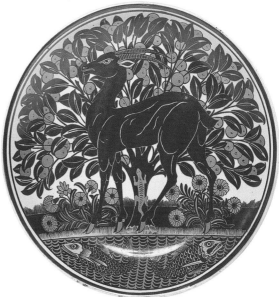

72 (above). William de Morgan, dish with antelope and fruit tree. Lustre decoration in red on Staffordshire blank, c.1880. V&A: 832-1905. The new museums in South Kensington, established after the Great Exhibition of 1851, had an important role in educating artists and designers. Their displays made a strong impression on the potter William de Morgan, who adapted Iznik patterns and lustre glazes for his own ceramics.

INDIA

The East India Company extended its influence across the subcontinent in the first half of the nineteenth century, and became *de facto* rulers of much of India. The Indian mutiny of 1857 made it was clear that the Company could no longer retain overall control and, once the revolt was quelled, the Crown took over direct power. Then in 1876, in a dramatic gesture, Prime Minister Disraeli established Victoria as Empress of India.

This relationship with India was of central importance to the British people. It signified the spread of British influence, bringing political stability and education in its wake. In return, the colonial power could enjoy the vast wealth of India, which was displayed triumphantly at the Great Exhibition of 1851, and on many subsequent occasions.

Displays of Indian textiles, metalwork, jewels and carvings at international exhibitions partly contributed to a popular market for Indian goods. The textile industries of Britain and India became interdependent, as low-grade cottons were exported to the colonies, and silk was brought back to be worked in Britain.

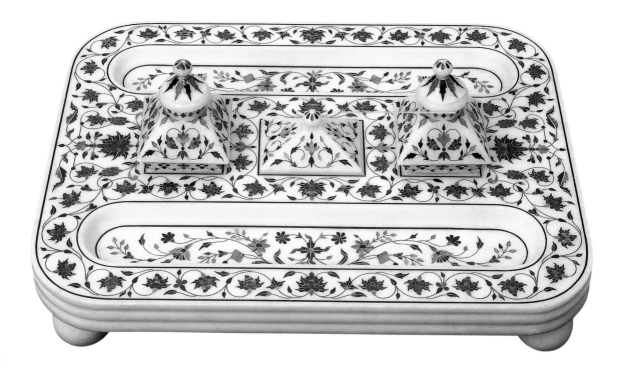

74 (right). George Haité,
design for a Paisley shawl.
Watercolour, c.1850.
V&A: E.4110-1911.
Shawls imported from
Kashmir, with their
distinctive patterns, were
copied by British weavers,
and were particularly
associated with the woollen
mills of Paisley in Scotland.

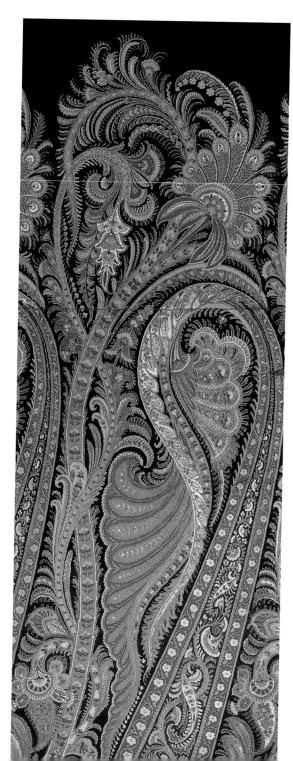

73 (left). Inkstand. Inlaid
alabaster, shown at the
Great Exhibition of 1851.
Made in Agra, India. V&A:
951-1852.
The Indian Court at the
Crystal Palace demonstrated
the sophistication and
wealth of India to the
European public as never
before. The display of a
stuffed elephant, bearing a
magnificent howdah, was
particularly popular.

The COLONIAL
and INDIAN
EXHIBITIO
1886

SUPPLEMENT
to the
ART JOURNAL

75 (above). The Colonial and
Indian Exhibition. Art Journal
Supplement, 1886. V&A: NAL.
At the Colonial and Indian
Exhibition of 1886, the art
and products of the Empire
were laid out in London.
Indian craftspeople were
brought over to Britain to
create carved architectural
settings for these objects.
Some of their work still
survives, including a
magnificent durbar hall now
on display in Hastings
Museum.

THE AMERICAS

For many Victorians the Americas felt like part of Greater Britain, as nearly two-thirds of all emigrants headed for the USA, and many families also had relatives recently settled in Argentina or Canada. The gold rushes of 1849 in California and 1896 in Alaska encouraged a flurry of activity, but throughout the century there was a steady stream of Britons ready to try their luck overseas.

The white emigrants and explorers who were supplying the export market were encountering other native cultures as they spread across the country. In some cases they tried to understand the people who originally held the land, and began to categorise the functions of the masks, weapons and other objects that they were able to collect. In general, however, North American ethnographic objects made little impact on professional designers in the nineteenth century. They were displayed as curiosities rather than art objects. South American objects were occasionally treated differently. Pre-Columbian pottery was included in the collections of museums as far apart as Exeter and Edinburgh before 1900, and did attract the attention of a handful of designers.

It was the innovative products from the USA that caused a stir back in Britain. Sewing machines and typewriters transformed the working lives of many Victorians, and proved to be far more desirable and revolutionary than anything that could be offered by the Inuit or Inca.

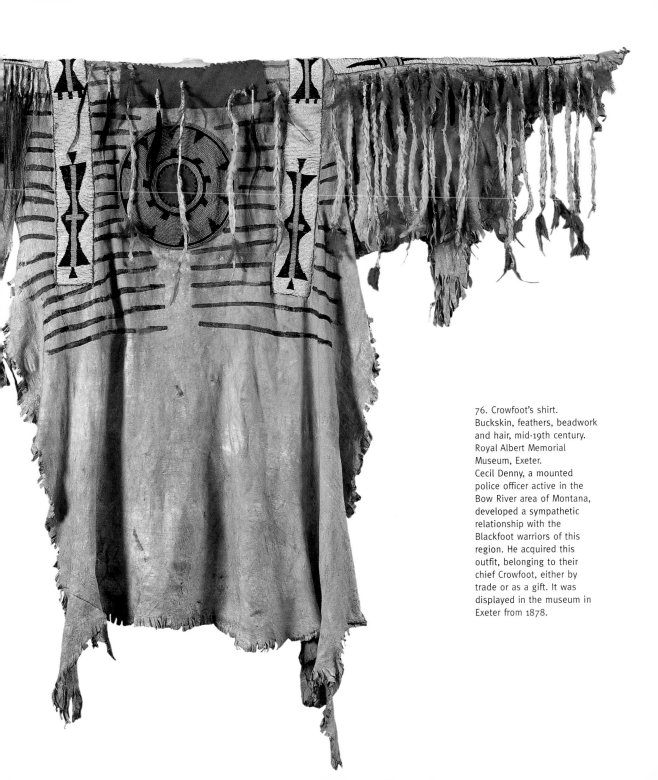

76. Crowfoot's shirt. Buckskin, feathers, beadwork and hair, mid-19th century. Royal Albert Memorial Museum, Exeter.

Cecil Denny, a mounted police officer active in the Bow River area of Montana, developed a sympathetic relationship with the Blackfoot warriors of this region. He acquired this outfit, belonging to their chief Crowfoot, either by trade or as a gift. It was displayed in the museum in Exeter from 1878.

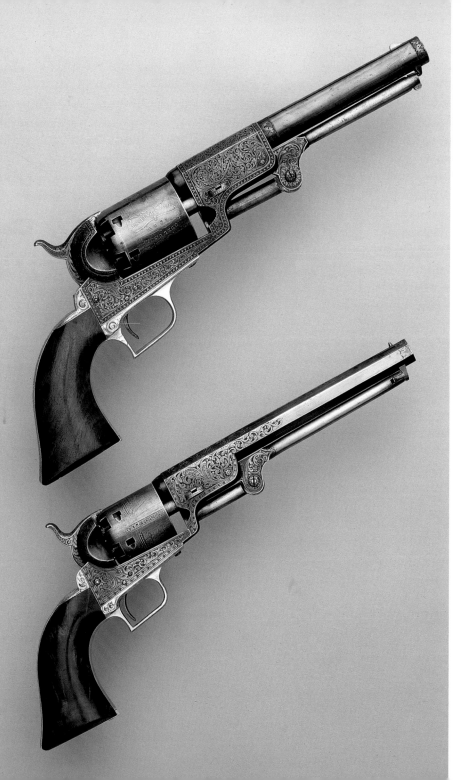

77 (left). Colt revolvers.
Presented to the Prince
Consort at the Great
Exhibition, 1851. The Royal
Collection © HM Queen
Elizabeth II.
Modern American objects
had a great influence on
British design. The method
of manufacturing Colt
revolvers, with inter-
changeable parts that could
be obtained through a mail-
order catalogue,
demonstrated that American
approaches could
revolutionise industry.

78 (right). Feather fan. Rio
de Janeiro, late 19th century.
V&A: T.15-1950.
Hummingbird and bird of
paradise feathers from South
America were a distinctive
feature of European fashion
throughout the century.
However by the 1880s, some
groups were raising
awareness of the decimation
of the bird populations as a
result of this trade.

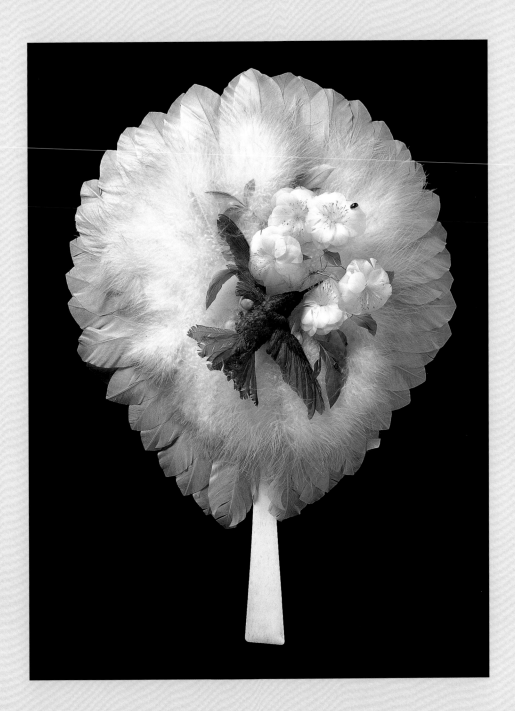

THE PACIFIC

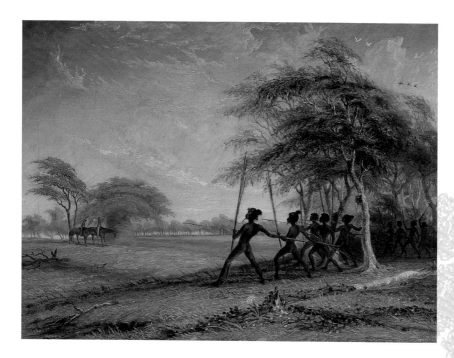

79. Thomas Baines, *Baines and Bowman Meeting a Hostile Tribe*. Oil on canvas, 1855. Royal Geographical Society, London.
As in other colonies, European arrivals to the Pacific islands had to contend with the original inhabitants. In New Zealand, the Maoris protested fiercely against the establishment of British rule. These protests erupted periodically, and from 1843 to 1848 there were periods of guerrilla warfare. Conflict continued throughout the 1860s, and had to be suppressed by British and Australian troops, supporting the local militia.

As with the Americas, Victorian responses to the Pacific had to distinguish between modern, white settlement cultures, and the indigenous populations. Although the early history of Britain's relationship with Australia had been scarred by the transportation of convicts, by 1853 the practice was dwindling, and in 1867 it stopped altogether. A measure of self-government was granted to all Australian colonies in 1855, and in 1856 Tasmania and New Zealand were offered the same limited independence. The gold rush of 1851 had encouraged large numbers of respectable British families to seek their fortunes in 'the diggings', with varying success, and the Pacific colonies had given some the chance to better themselves.

Despite opposition, British rule gradually spread across the Pacific. Fiji became a colony in 1874, Papua was added to the Empire in 1884, and the Cook Islands were made a Protectorate in 1888. At every stage, the British influence was reinforced by administrators, missionaries and entrepreneurs. As they came into contact with the local cultures, some began to collect local religious and domestic objects to be displayed in museums.

80. Tatanua mask. Oceania, Melanesia, New Ireland, before 1900. Pitt Rivers Museum, Oxford.

Sometimes islanders offered examples of their art as gifts to the settlers. In other cases, items were stolen. But frequently Europeans were able to trade for objects to add to their collections. George Brown, a Methodist missionary working in New Ireland in 1880, described how 'the natives in this part brought off great numbers of the most grotesque-looking wooden masks, and also some rather elaborate wood-carvings. These they readily sold for hoop iron'.[3]

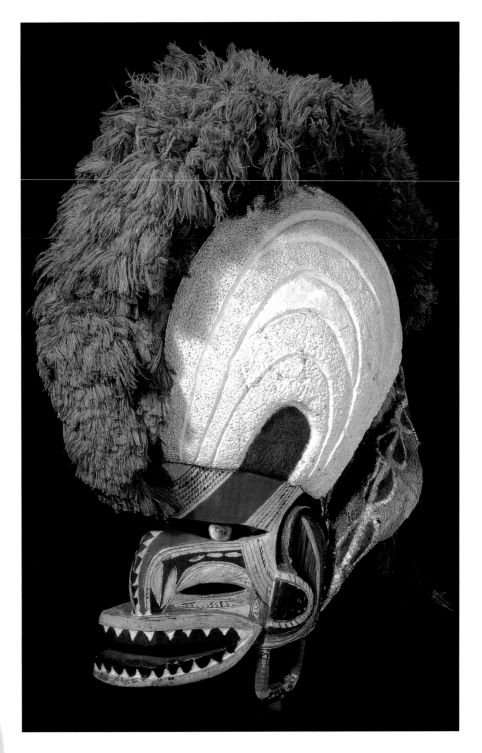

AFRICA

African objects were generally criticised as barbaric and superstitious, and it was not until the dawn of the twentieth century that they had any direct influence on western artists or designers. However, the continent did have a significant impact on the Victorian imagination. Countless stories and paintings retold the deeds of the British in Africa. Newspaper readers were held spellbound by General Gordon's bloody fate at the hands of the Islamic army of the Mahdi, when Khartoum finally fell in 1885 after a prolonged siege.

Of course, it was the strategic importance and potential wealth of the 'dark continent' that attracted British explorers, soldiers and entrepreneurs in the first place. Henry Morton Stanley's expedition in the Congo, for example, was largely driven by a desire to open up the palm oil and ivory trade for Britain. When gold and diamonds were discovered in Southern Africa in the 1880s Britain was determined to stabilise its position in South Africa, at the expense of the Boer settlers. This policy led to the costly Boer wars (1880–1 and 1899–1902), when the British suffered a series of humiliating defeats before the Boer resistance was worn down.

81. Sculpture of the Queen Mother. Benin, early 16th century. National Museums and Galleries on Merseyside. Members of a military expedition to the kingdom of Benin (Nigeria) in 1897 brought back to Britain ivory carvings and brass figures. The sophisticated techniques that were involved in making large sculptural heads of the *oba* (king) and his mother astonished Victorian anthropologists, who found it hard to accept that these works had been made in the 16th century without European assistance.

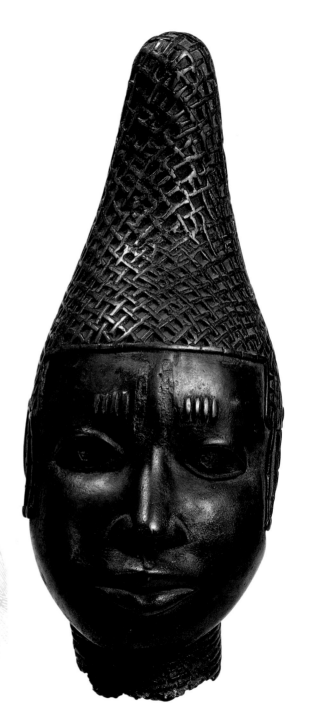

82 (right). G. Durand after H.M. Stanley, *The meeting of Livingstone and Stanley in Central Africa*. Wood-engraving from the *Graphic* (3 August 1872). By courtesy of the National Portrait Gallery, London.
Explorers such as David Livingstone and Henry Morton Stanley became national heroes when their expeditions were publicised in books and newspaper reports. Livingstone's discovery of the Victoria Falls, and his encounter with Stanley in 1871, were celebrated events; the Queen was so relieved to hear that Livingstone had been found, that she presented Stanley with a diamond-encrusted snuffbox.

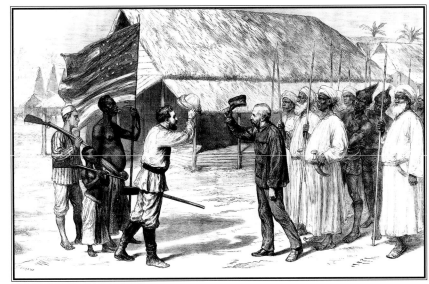

83 (below). Lady Butler, *The Defence of Rorke's Drift*. Oil on canvas, 1880. The Royal Collection © HM Queen Elizabeth II.

British artists were often more interested in depicting their army's defeats or heroic last stands than the confidence of victory. Encounters with the mighty Zulu army, with the British defeat at Isandhlwana and then the valiant defence of the mission station at Rorke's Drift, very quickly became the stuff of legend.

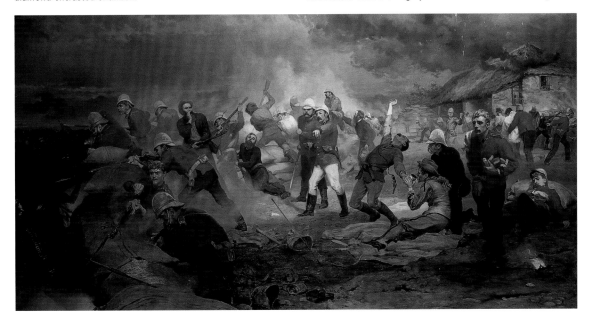

Conclusion

By the end of the century, the British Empire was well established as a political, social and economic force, with influence in every continent. Familiarity with the Empire and all it stood for was universal in Britain, thanks to modern communications, newspapers, photographs and the direct experience of emigration, travel and colonial life. At the same time, the apparent security of Britain's position as a major trading nation was increasingly being undermined by the expansionist ambitions of European rivals and the rapid development of American technology. National confidence had been seriously shaken by the Boer War, and the partition of Africa among eight nations. Over the next decades, other powers would continue to challenge and ultimately eclipse British influence in the world, but they were only able to do so through the application of technology and economic principles that had been established by the Victorians.

Notes on Text

1. Ruskin, John. *Praeterita*, quoted by Kenneth Clark in *Ruskin Today* (London 1964), p.31.
2. Gladstone, Mary. *Diary*, quoted by Joanna Banham, Sally Macdonald and Julia Porter in *Victorian Interior Design* (London 1991), p.204.
3. Quoted by Steven Hooper in *Robert and Lisa Sainsbury Collection: catalogue in three volumes* (New Haven and London 1997).

SELECT BIBLIOGRAPHY

Auerbach, J.A. *The Great Exhibition of 1851: A Nation on Display* (1999)

Bayly, C., ed. *The Raj: India and the British, 1600–1947* (1990)

Benson, John. *The Working Class in Britain, 1850–1939* (1989)

Briggs, Asa. *Victorian Cities* (1968)

Brooks, Chris, and Andrew Saint, eds. *The Victorian Church: Architecture and Society* (1995)

Bynum, W.E. *Science and the Practice of Medicine in the Nineteenth Century* (1994)

Carter, Tom. *The Victorian Garden* (1984)

Chrimes, Mike. *Civil Engineering 1839-1889: A Photographic History* (1991)

Desmond, Adrian, and James Moore. *Darwin* (1991)

Driver, Felix, and David Gilbert, eds. *Imperial Cities* (1999)

Girouard, M. *The Victorian Country House* (979)

Golby, J., and W. Purdue. *The Making of the Modern Christmas* (1986)

Gray, R.Q. *The Factory Question and Industrial England* (1996)

Greenhalgh, Paul. *Ephemeral Vistas: The Expositions Universelles, Great Exhibitions and World Fairs, 1851–1839* (1988)

Guy, Alan J. and Peter B. Boyden. *Soldiers of the Raj* (1997)

Hardyment, C. *Home Comfort: A History of Domestic Arrangements* (1992)

Haworth-Booth, Mark. *Photography: an independent art 1839-1996* (1997)

Herchkowitz, Robert. *The British Photographer Abroad: The First Thirty Years* (1980)

Hewison, Robert, Ian Warrell, and Stephen Wildman, eds. *Ruskin, Turner and the Pre-Raphaelites* (2000)

Hibbert, Christopher, ed. *Queen Victoria in her Letters and Journals* (1984)

Hobsbawm, Erik and T. Ranger, eds. *The Invention of Tradition*, E. Hobsbawm (1983)

Hopkins, Eric. *Childhood Transformed: Working-Class Children in Nineteenth-Century England* (1994)

Horn, Pamela. *The Rise and Fall of the Victorian Servant* (1995)

Knight, Frances. *The Nineteenth Century Church and English Society* (1995)

Lambourne, Lionel. *Victorian painting* (1999)

Longford, Elizabeth. *Victoria RI* (1964)

Lowerson, John. *Sport and the English Middle Classes, 1870–1914* (1993)

Lummis, Trevor, and Jan Marsh. *The Woman's Domain: Women and the English Country House* (1990)

MacKenzie, John M., ed. *Imperialism and Popular Culture* (1986)

MacKenzie, John M. *The Empire of Nature: Hunting, Conservation and British Imperialism* (1988)

MacKenzie, John M. *David Livingstone and the Victorian Encounter with Africa* (1996)

Mason, Michael. *The Making of Victorian Sexuality* (1994)

Matthew, H.C.G. ed. *The Nineteenth Century: the British Isles 1815-1901* (2000)

Pakenham, Thomas. *The Scramble for Africa* (1991)

Richardson, Brenda, and Malcolm Baker, eds., *A Grand Design: The Art of the Victoria and Albert Museum* (1998)

Morris, Barbara. *Liberty Design* (1989)

Musgrave, Toby, Chris Gardner, and Will Musgrave. *The Plant Hunters: Two Hundred Years of Adventure and Discovery Around the World* (1998)

Newsome, David. *The Victorian World Picture* (1997)

Parry, Linda. *William Morris* (1996)

Phillips, Tom, ed. *Africa: The Art of a Continent* (1995)

Porter, A.N., ed. *Atlas of British Overseas Expansion* (1991)

Porter, Andrew, ed. *The Oxford History of the British Empire*, vol.3, *The Nineteenth Century* (1999)

Read, Benedict. *Victorian Sculpture* (1982)

Renton, Alice. *Tyrant or Victim? A History of the British Governess* (1991)

Robinson, Jane. *Unsuitable for Ladies: an anthology of women travellers* (1994)

Russell, D. *Football and the English* (1997)

Ryan, James R. *Picturing Empire: Photography and the Visualization of the British Empire* (1997)

Said, Edward W. *Culture and Imperialism* (1993)

Sato, Tomoko, and Toshio Watanabe eds. *Japan and Britain: An Aesthetic Dialogue, 1850–1930* (1991)

Smith, B. *European Vision and the South Pacific* (1985)

Smith, N. and E. Darby. *The Cult of the Prince Consort* (1983)

Stanley, Brian. *The Bible and the Flag* (1990)

Stuart, David. *The Garden Triumphant: A Victorian Legacy* (1988)

Thorne, Robert, ed. *The Iron Revolution: Architects, Engineers and Structural Innovation 1780–1880* (1990)

Vamplew, W. *Play Up and Play the Game: Professional Sport in Britain 1875–1914* (1988)

Walton, J.K. *The English Seaside Resort: A Social History, 1750–1914* (1983)

Warner, Marina. *Queen Victoria's Sketch Book* (1979)

Waterfield, Giles. *Palaces of Art: Art Galleries in Britain, 1790–1990* (1991)

Weintraub, Stanley. *Victoria, Biography of a Queen* (1987)

Weintraub, Stanley. *Albert, Uncrowned King* (1997)

INDEX